D1467559

NO LIMITS

JANET BIGGS

This catalogue was published
on the occasion of the exhibition
No Limits: Janet Biggs,
organized by the Tampa Museum of Art,
curated by Todd D. Smith,
8 October 2011– 8 January 2012.

Support for this exhibition has been
provided by the Tampa Museum of Art
Foundation, members of the Tampa
Museum of Art, and Pride and Passion
2010. Media support has been provided
by *St. Petersburg Times*. Support for the
publication of the exhibition catalogue has
been provided by Philanthropic Young
Tampa Bay and Anonymous supporters.

Contents

Foreword

By Berta Sichel

Video artist Janet Biggs' work has always focused on individuals enduring hardship.

For the exhibition *No Limits: Janet Biggs*, Biggs selected twelve videos (three multi-channel installations and nine single-channel videos) which cover more than ten years of her 28-year career. While watching them, my thoughts turned to travel writing, particularly accounts by a number of English women during the late nineteenth century, at the height of the British Empire.

Although separated by more than a century, Biggs' videos and the travel writings I associate with them spring from a similar imagination. They reflect their authors' courage in venturing to distant places and the desire to turn their experiences into new narratives, which include both personal experience and geographic record.

The art historian Alison Blunt has discussed the writing of Mary Kingsley and other European women who used travel narratives for both journalistic and metaphorical ends (*Mapping Authorship and Authority: Reading Mary Kingsley's Landscape Descriptions* in *Writing, Women and Space: Colonial and Postcolonial Geographies,* ed. A. Blunt and G. Rose, 1994). When Kingsley published her first book, *Travels in West Africa* (1897), the reviews focused on the novelty of a woman traveler and noted, among other things, that there was no limit to female curiosity. The reviews noted women were not interested in making scientific records, as their male contemporaries were. Most of the women left comfortable lives in London to cross borders and oceans, mountains and deserts; in recording their journeys, they created a new discourse.

Their reliance on and confidence in their native guides (always male) were not only examples of early feminism but also confirmation that the women had the courage, despite social disapproval, to venture into a male-dominated arena. In looking at travel writers during the late nineteenth century, it becomes clear that the women were more concerned with establishing their own identities and exercising their sense of personal independence than in contributing to academic knowledge or telling adventure stories—both of which interested the men.

Imperial expansion provided unprecedented opportunity for European, middle-class women to travel unchaperoned, but their desire for adventure was not exclusively for its own sake. According to recent scholarly writing, such as *Writing, Women and Space: Colonial and Post Colonial Geographies* (1994), the interest in travel to places previously inaccessible to women was fundamentally motivated by the attempt to write the largely unrecorded histories of women.

While critics acknowledged the hardships Kingsley confronted, they also emphasized the incommensurability of her journey with the scientific explorations of European men who had traveled in uncharted lands. Kingsley, of course, had faced the same uncertainties and dangers of any European travelling in Africa; her writing reflects her individuality and establishes her authority. Yet, many reviewers called her long journeys a "walk." Biggs, like Kingsley, neither fears unknown territories nor claims a "fixed authority" as traveler and narrator. (Nancy Princenthal explores these subjects in her essay in this catalogue.)

Biggs established new parameters and broke limits within the field of video, much as the women writers of the colonial period broke the limits that society had imposed upon them. Some of Biggs' themes are conventionally associated with a male sensibility but, as in the nineteenth-century women's travel accounts, they are centered on places of resistance and, as Princenthal notes, they set new parameters both in scale and perspective. She begins her essay, *Going to Extremes* saying, "The limits of endurance, the ends of the earth, the furthest recesses of consciousness—Janet Biggs' subjects tend to lead her to extremes."

Just as the early female pioneer travelers discovered, Biggs, too, learns about and examines the inadequacy of mapping a linear route. We see this particularly in *Duet* (2010) and in her most recent videos, *The Arctic Trilogy* (2010–11). There's another artistic example of mapping out new routes that Andrea Inselmann examines in this catalogue.

Inselmann's essay looks closely at road movies from the 1970s and explores the relationship of Biggs' videos to those mainstream films. So there is an easy connection between the adventures and bravura of those nineteenth-century women travelers and the road movies we know today. Both Biggs and her defiant and adventurous predecessors cross new borders and leave cosmopolitan places to journey to distant cultural and geographic locations. Biggs "remaps" faraway landscapes and radical sports (another conventionally male subject) and ties gender to ideas of identity and self-empowerment. Inselmann also focuses on the turning point of Biggs' work, *Vanishing Point* which functions as a bridge between her earlier pieces, such as *Girls and Horses* and *Water Training*.

Technology offers the possibility of modeling new environments and conceiving new ways of thinking. The medium of video allows different levels of conceptualization and communication than does print. The digital circulation of those images captured on video allows for even wider distribution and consciousness.

The international artistic zeitgeist sees recurring themes in exploration, mapping, charting, travelling, and space. So does Janet Biggs. But she goes deeper than mere adventure to answer questions like: What do images say? How do they interact with their viewers? What associations with their own histories do images bring? How do images change narratives?

Women have been seeking adventure in unknown lands since at least the nineteenth century. Biggs is part of a long, proud line of female thrill-seekers who have sought to record their adventures and discoveries. Her courage and the art that's come from it are a tribute to all who came before.

Berta Sichel is an independent curator, writer and Curator at Large at the Museo Nacional Reina Sofia, Madrid, where she was Director of the Department of Audio-visuals and Chief Curator for Cinema, Video, and Multimedia from 2000-2011.

The Verge: Janet Biggs

By Todd D. Smith

This essay first appeared in 2001 as an accompanying brochure to the exhibition The Verge: Janet Biggs *(July 12 - September 30, 2001) at the Plains Art Museum, Fargo N.D. The author thanks the Plains Art Museum for their generosity in granting publication rights of the essay for this catalogue.*

Janet Biggs explores two themes in her video installations: female sexuality and the relationship between individuals and pharmacology. At first these appear unconnected and unrelated, and on most levels they are. Yet, there is a thread (tenuous at first glance) of connectivity between these two. It might be as simple as the artist's own life that forms the thread, but I suggest that it is a much more subtle, almost undetectable current, that binds. The works cohere around the topic of freedom—whether personal, sexual, or medical—and the claims that social institutions, which monitor these freedoms, place on the expression of freedom.

On the heels of the prominent discourse on the construction of gender and sexuality in the visual arts that pervaded the 1990s, how do artists in the wake of this hyper-concentrated endeavor revisit the issues of gender and sexuality? Biggs is successful in taking the project beyond the traditional treatment of masculine as active and feminine as passive: the male, the viewer; the female, the viewed. What Biggs offers is, instead, a nuanced reading of gender within contemporary society through the mechanisms of power and control.

This essay begins and ends with a treatment of two works (*Glacier Approach,* 1997, and *BuSpar,* 1999). Their connectivity is provided by the modulations of purpose, which take us from the topic of female sexuality to the impact of pharmaceuticals on individuals, all the while keeping an eye toward the issue of freedom as a lurking concern for Biggs and her subjects.

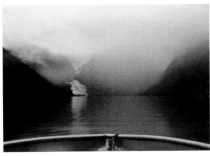

In *Glacier Approach,* Biggs tackles the frozen waters of adolescent female sexuality. Freudian to a tee, the work denies and yet celebrates the subjugated place of such sexuality in the traditional program of twentieth century psychoanalytic discourse.

A singularly beautiful landscape composition, caught through a ship's bow viewfinder, is radically severed by the jarring glimpse of a female swimmer's body, which helplessly flounders in the direct path of a ship. At first, the narrative of the work should be easily read and understood. A ship approaches a glacier, as simple as the title itself. As the viewer is about to be lulled by this prosaic treatment, a blip occurs, and as the loop continues, more blips occur. The viewer becomes less interested in the beauty of the glacier's approach and more compelled by that which interrupts the approach.

To understand this intrusion, the viewer must spend more and more time on this video glimpse and leave behind the totalizing video treatment of the ship's

movement and the "supposed" object of desire: the glacier. The disruptions confuse and finally frustrate the viewer, who seeks narrative seamlessness and eventual closure. The conclusion—the reaching of the glacial summit—fails to provide normal filmic closure as the viewer is haunted by the image of the swimmer. The pleasure of the ending never can be realized, especially for Biggs, who refuses to leave alone the problems associated with the sublimation of desire.

The swimmer's appearance is a blot, a blemish on the face of the landscape. For Biggs' project, this is fine ... even preferable. The nature of early sexual sublimation is such that it functions as a negative mark on acceptable sexual mores. The presence of the young female swimmer suggests what is at stake with the regulation of this early sexuality: danger. On a visceral level, the viewer begins to experience the danger that the frigid water means for the swimmer; as the viewer thinks about the swimmer more, the symbolism of the frigid water moves into the forefront. This frigidity highlights the regulatory administration needed.

Biggs' career has been characterized by this investigation of the peculiarities of adolescent female sexuality, and in particular, these inquiries have been directed at the relationship between girls, horses, and the strong attraction of the former for the latter. In the social context of the United States for a certain group of young women, equestrianism is a lofty hobby, one complete with generations of breeding for both the horses and the girls. For suburban and urban young girls, horseback riding—and even more importantly, horsemanship—signifies social standing, and the luxury of riding can be measured in both the freedom it affords and the financial investment on behalf of the family.

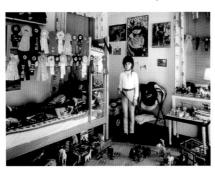

A trained equestrian herself, Biggs has explored this cultural phenomenon for several years. One of her first treatments of the subject was in photography: her image *Celeste in Her Bedroom* (1996) is a large-scale (4' x 7') color print of a young girl donning a simple riding outfit, surrounded in her domestic enclave with the trappings of equestrian accomplishment. Her ribbons from shows are offset by the myriad of toy horses that grace every surface in the bedroom. The subject gazes directly at the viewer, and, while diminutive among her furnishings, Celeste commands the scene. The crux of the photograph, however, is provided by the careful placement of the riding crop across Celeste's own crotch. An appendage, the crop signifies control and mastery, and the subject's countenance betrays the guilty pleasure she derives from such control. The question becomes, however, over what does she gain control: the horse or her own sexuality.

That same year, 1996, Biggs took this examination of the physical act of riding only alluded to in *Celeste*—further to explore it as a site for the expression of emerging sexuality. Her *Girls and Horses* installation forcibly engages this very issue through a variety of aesthetic choices. The installation consists of a projected image of a young girl riding a real horse and several monitors, which are broadcasting video footage of young girls in ersatz riding activities. These include girls riding a carnival-ride pony, a toy horse fabricated from a stick, and a coin-operated rocking horse. Complementing this display are other monitors that transmit images of young girls

playing "horsey" with their parents. While seeming innocuous enough, these latter images are in fact some of the most unsettling within Biggs' *oeuvre*, for their meaning is modified by their context within this discussion of ripening sexuality. In fact, and to be more specific, this imagery is disturbing not in what it indicates about perversity about young girls, their older male "horses," the artist or the critics, but in what it indicates about how thinly veiled the connection between childhood bliss and sexual pleasure really is.

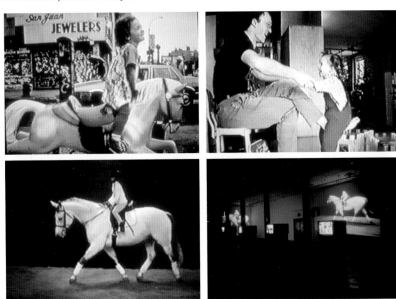

Water Training (1997) continues Biggs' interest in the relationship between females and horses, but in this instance the sexuality operates on a more connotative level and through a more complicated avenue. Two projections are positioned at right angles to each other; on the right wall, the actions of a pair of synchronized swimmers are presented, and on the left wall, a horse labors to swim in a pool. The juxtaposition of the grace and agility of the two swimmers and the lumbering activities of the horse draws attention to the distance between these two aquatic endeavors; yet, at the same time, the juxtaposition foregrounds the determination and concentration that support each, and the dis-ease that each character experiences while maneuvering through the water.

Critic Andrea Inselmann has argued, with respect to *Water Training,* that the work offers a none-too-subtle interrogation of gender roles in contemporary society. Concentrating on the swimmers' movements, Inselmann contends, "Biggs focuses on the constructedness of the sport and, by extension, the construction of femininity." Inselmann further makes the point that Biggs' depiction of synchronized swimmers within a cinematic context hearkens back to the glory days of Busby Berkeley and Esther Williams. Yet, as the critic rightly clarifies, Biggs' project is at odds with the codification of gender roles epitomized by such Golden Era Hollywood offerings. For Biggs then, the display of the underwater workings, the mechanism as it were, of synchronized swimming finds a parallel in the horse's discomfort as it makes its way through the water. If the women's actions represent a heightened femininity and the power of the horse masculinity, then *Water Training* successfully reveals

the great effort necessary to uphold each gender norm and the unnerving quality that accompanies the exposure of such gender operations. Finally, the work likewise demonstrates the lack of freedom that accompanies the rigidity of gender codification.

If *Water Training's* focus on synchronized swimming provides a certain campiness to Biggs' intent, then her more recent *BuSpar* catapults the viewer back into the realm of the utterly serious. Likewise, *BuSpar* allows the spectator less wiggle room. The images are more arresting, disturbing and haunting … and the sound more unnerving. In this video installation, the viewer is enveloped in Biggs' world, for three video projections form a blackened hole that surrounds the viewer. In the center projection, a lone woman sits rocking back and forth in a generic chair while staring in the direction of a centrally located viewer. Flanking the middle-aged woman and captured in the same cinema verité style are two images of a horse's head, neck, and upper torso. The accompanying audio component records the sound of the horse as it canters in a circle. The spectator functions at times as mere observer and at others as participant, activating the work at various points of entry.

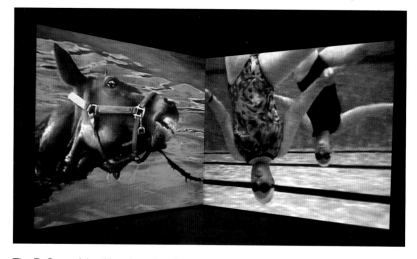

The BuSpar of the title refers directly to the drug that shares its name. The medication is prescribed for patients who suffer from mild anxiety and usually achieves the results of lessened anxiety gradually over a two- to four-week period. The drug also is used by veterinarians to treat horses.

The work revolves around the issue of movement and freedom. The horse, Pasha, is skillfully ridden around a circle, kept at a distance of 10 meters from the center and the artist. While not apparent in the video itself, Pasha is cantering, an act that requires a forceful enjoining of free agency. The movement and speed that often accompany traditional ideas of horseracing are circumvented by centering the movement into rigidly prescribed motions. Ironically, the speed of the lights behind Pasha's head convey a fast-paced activity and the freedom that should accompany such an action, yet the lights serve merely to belie the real lack of freedom that Pasha experiences. The elegant agility of dressage requires a collecting of energy within the horse and a subversion of the usual concept of the horse as free and unburdened by societal constraints.

Shifting attention to the woman who truly dominates the work, the female subject similarly is trapped by the lack of motion and freedom. Unbeknownst to the novice viewer, the woman featured in the work is the artist's aunt who suffers from autism and once was treated with BuSpar.

The title of the work directs the viewer to consider the consequences of this particular drug, i.e., the power of the drug to alter moods and actions. The focus on the effects of the drug also begs the question, "What is at stake with such drugs and, in the larger picture, is our society overmedicated?"

While the work does raise these questions, its real power comes from the engagement with the issues of power and restraint that undergird Biggs' *oeuvre*. Do the actions of the subjects in the work adversely affect their ability to gain power and control? Does the action of the artist in how she treats the subjects similarly strip the subjects of their agency or, more to the point, does the artist's capturing of the subjects serve to disclose the mechanisms within our society that maintain systems of power? If so, then we can return full circle within Biggs' work to the opening work in this essay, *Glacier Approach.*

Biggs unsettles her audience through the forceful revelation of the underpinnings of discursive power structures—whether these structures are the construction of gender norms, the medical apparatus that energizes the drug companies, or finally the attempts at supreme control that the rider affects over her horse during the intricacies of dressage. Biggs suggests that whatever the context, the result is the same: a struggle for domination that ends with an incoherent and often contradictory outcome. The ending never justifies the means for the actors in Biggs' non-narrative video world.

Since 2008, Todd D. Smith has served as executive director of the Tampa Museum of Art. In this role, he has overseen the construction and opening of the museum's award-winning new home and has curated and directed over 35 exhibitions since the reopening. Prior to Tampa, Smith served as the chief executive of the Gibbes Museum of Art in Charleston, SC, the Knoxville Museum of Art in Knoxville, TN, and The Plains Art Museum in Fargo, ND.

Earlier in his career, Smith served as curator of American and Contemporary Art at The Mint Museum of Art in Charlotte, NC, curator of American and Decorative Art at The Dayton Art Institute in Dayton, OH, and curator of collections at The Kinsey Institute at Indiana University in Bloomington, IN. Smith has lectured throughout the United States and Britain on American art and has published in the fields of American and contemporary art and museum studies.

Flight, 1999

Four-channel, standard
definition video installation with
sound and C-Print, 4:3 format.

Running time:
continuous loops of
1 to 3 minutes.

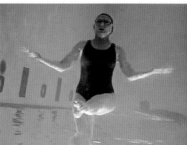
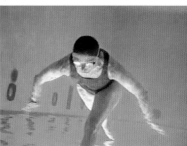
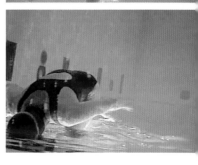

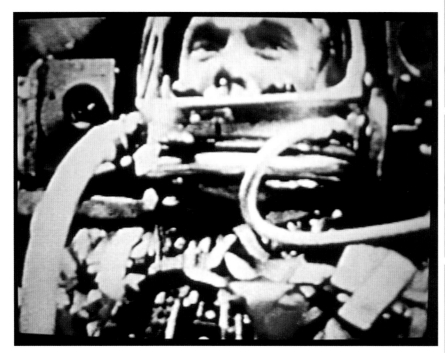

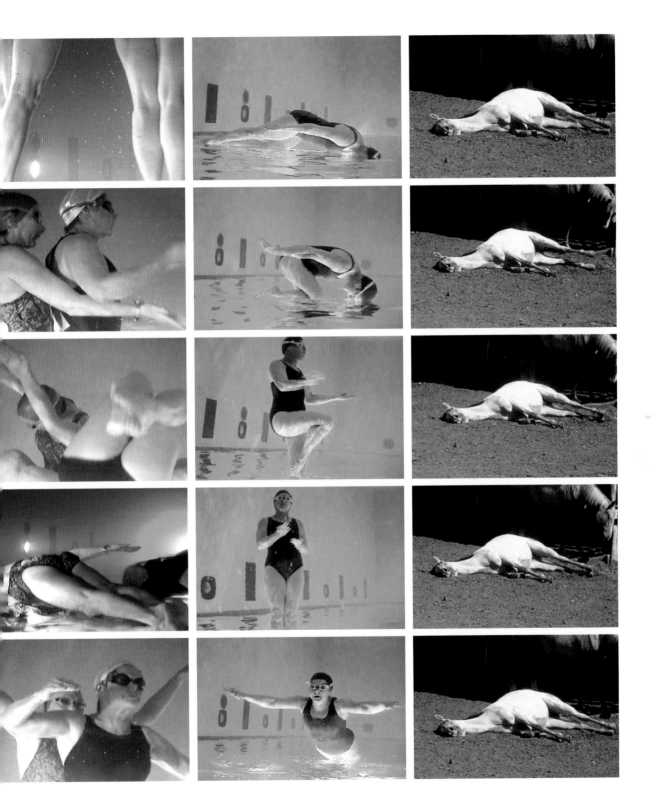

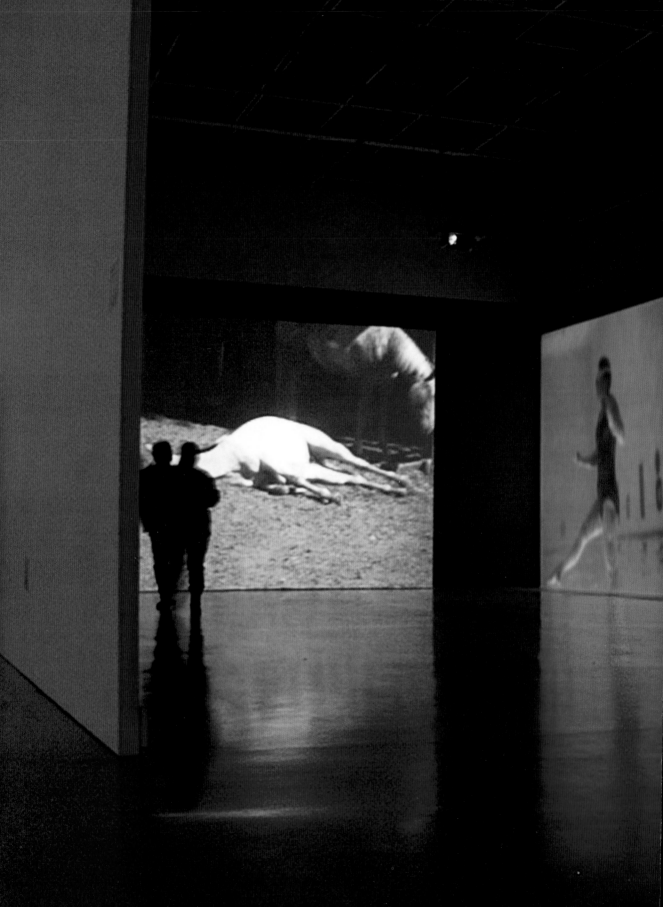

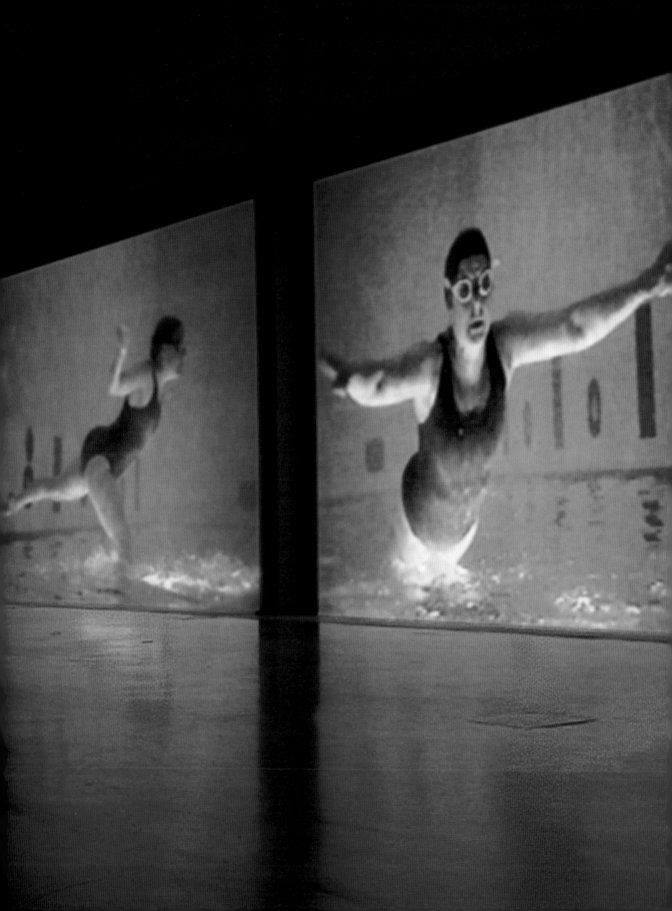

BuSpar, 1999

Three-channel, standard
definition video installation
with sound, 4:3 format.

Running time:
continuous loops
of 1 to 3 minutes.

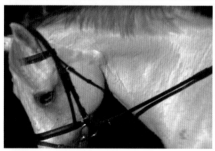

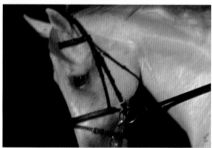

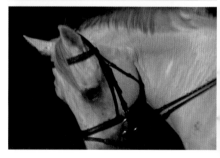

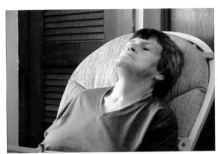
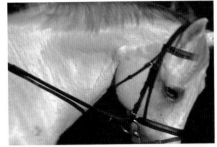
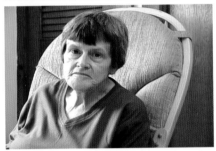
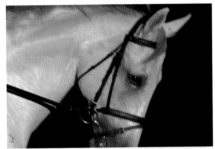
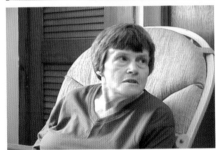
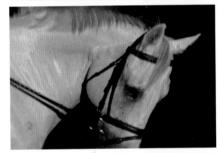
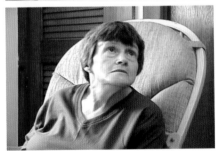

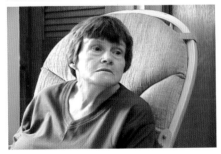
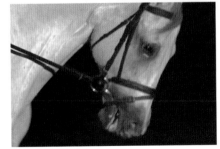

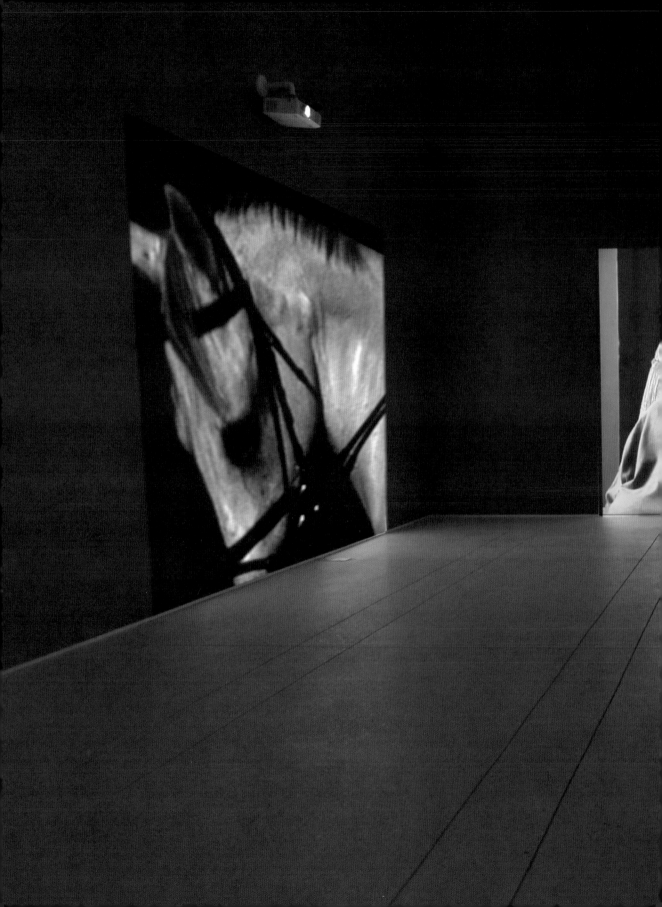

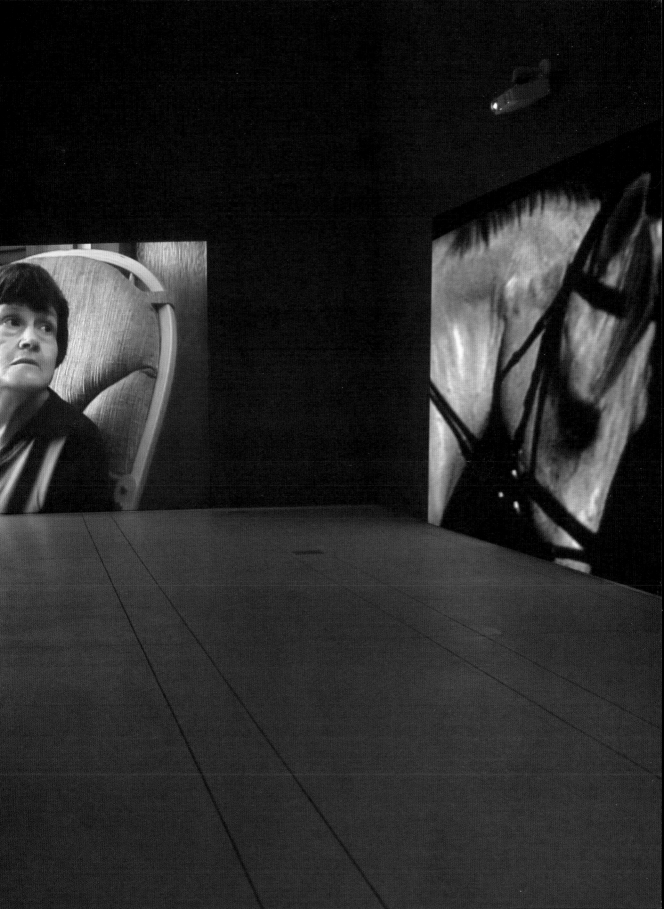

Carpe Diem, 2003-04

Two-channel standard
definition video installation
with sound, 4:3 format.

Running time:
continuous loops
of 1 to 2 minutes.

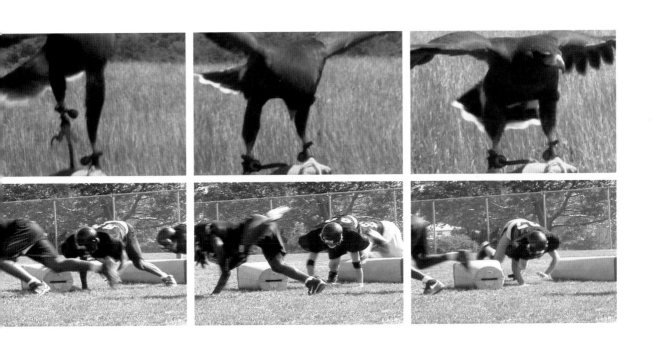

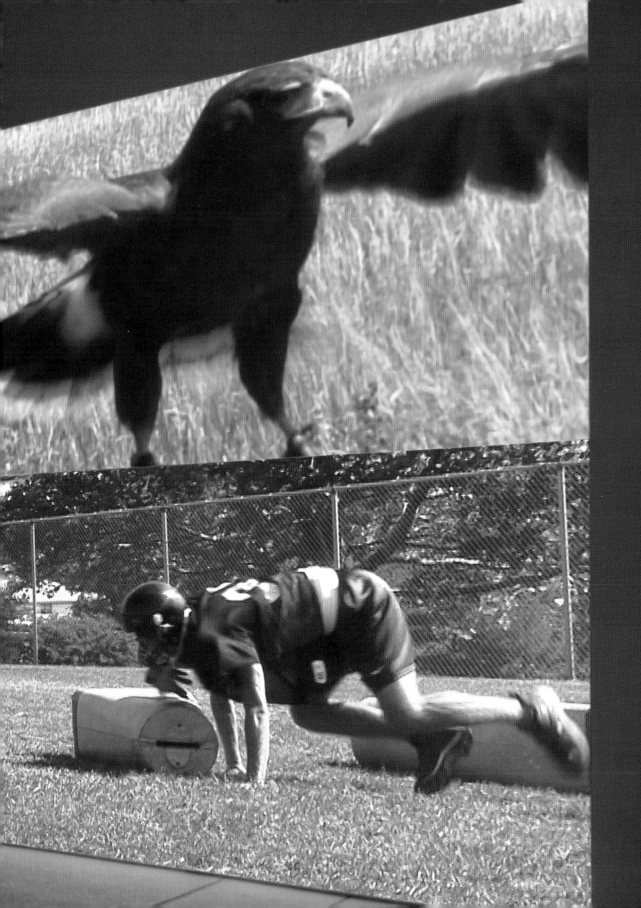

Chamblee, 2003

Single-channel, standard
definition video with sound,
4:3 format.

Running time:
00:02:23.

 00:15

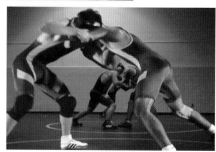 00:16

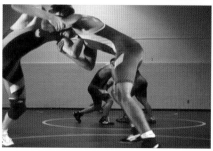 00:17

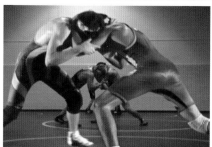 0:19

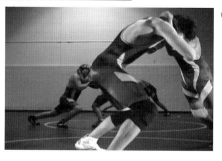 01:14

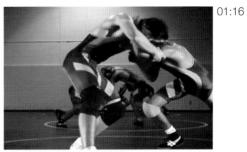

01:16

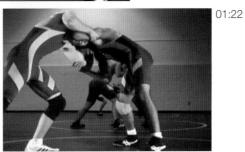

01:18

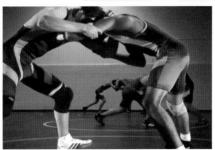

01:22

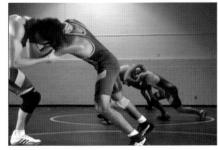

01:30

01:40

Bright Shiny Objects, 2004

Single-channel, standard definition video with sound, 4:3 format.

Running time: 00:04:43.

00:09

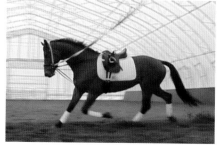

00:41

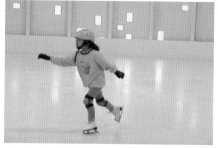

01:11

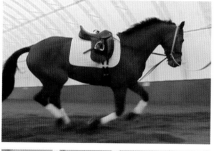

01:48

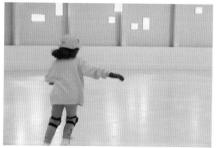

01:59

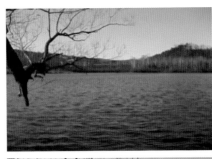 02:16

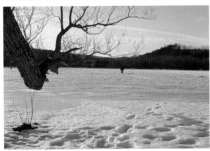 02:40

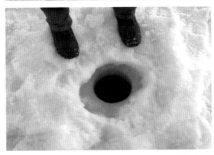 03:23

 03:.34

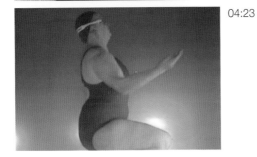 04:23

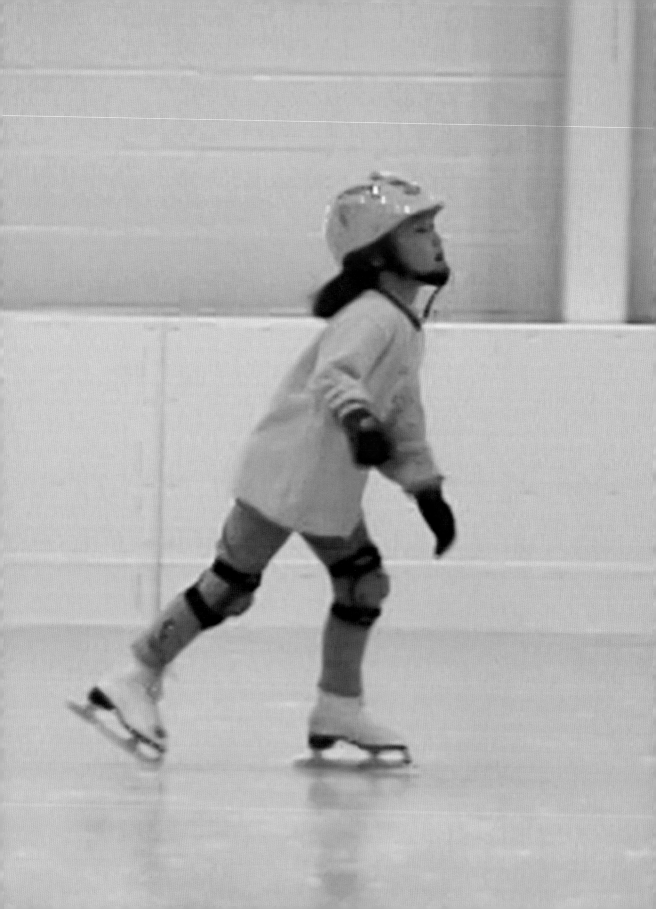

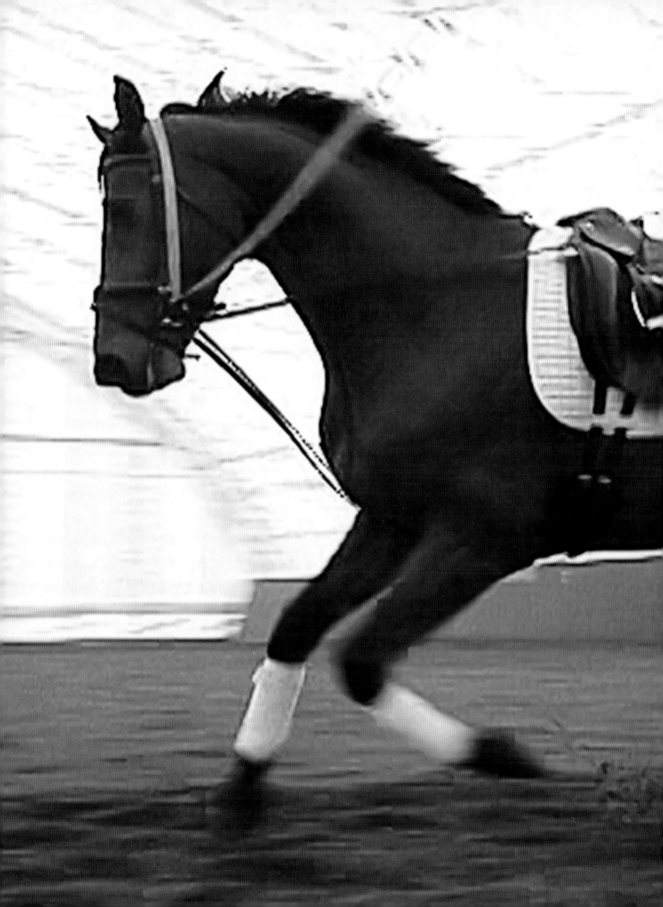

Airs Above the Ground, 2007

Single-channel, standard
definition video with sound,
16:9 format.

Running time:
00:05:21.

00:15

00:25

00:31

00:46

00:54

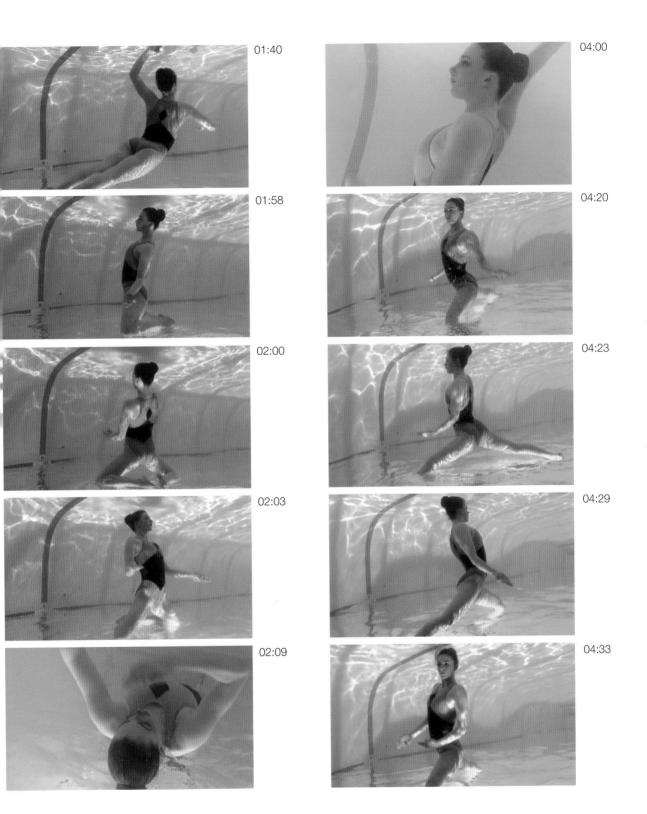

01:40

04:00

01:58

04:20

02:00

04:23

02:03

04:29

02:09

04:33

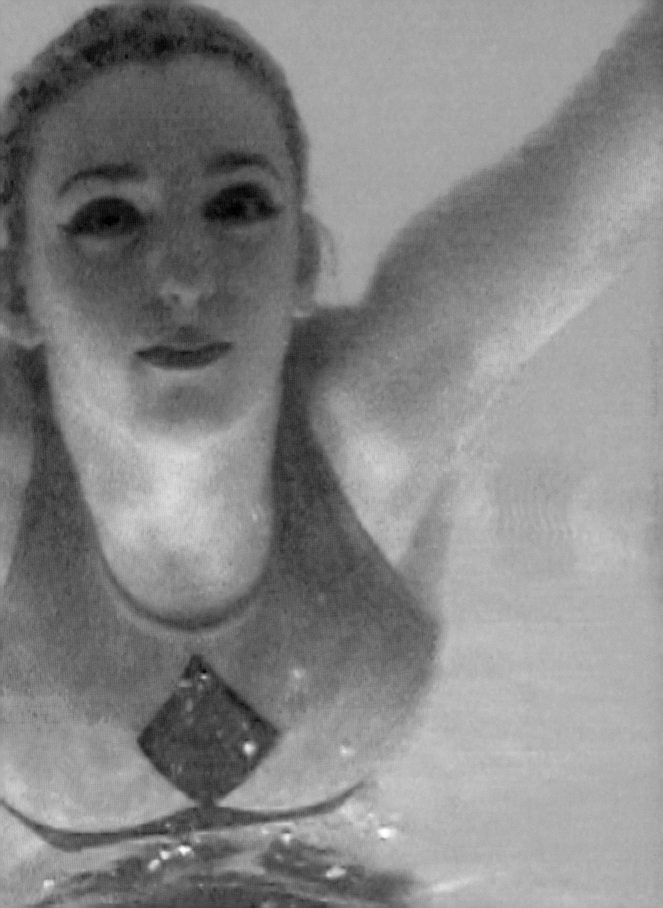

Fall On Me, 2006

Single-channel, standard
definition video with sound,
9:16 (vertical) format.

Running time:
00:04:13.

 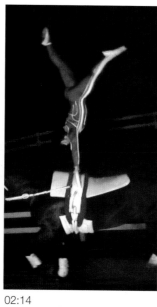 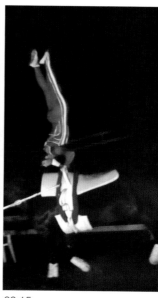 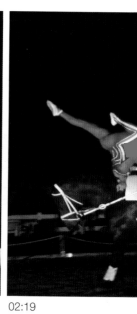

02:13

02:14

02:15

02:19

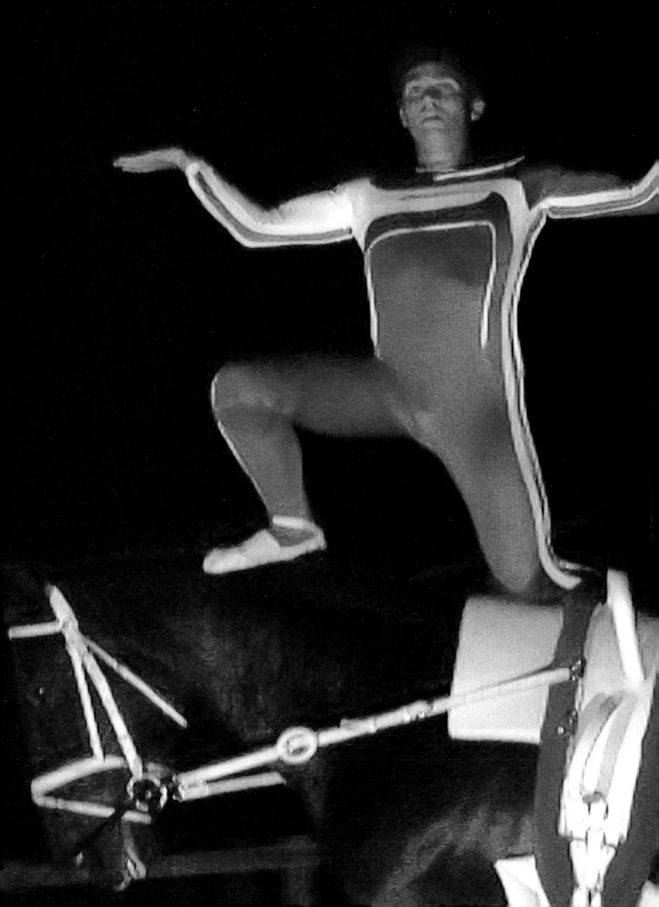

Like Tears in Rain, 2006

Two-channel, synchronized,
standard definition video
installation with sound,
4:3 format.

Running time:
00:07:16.

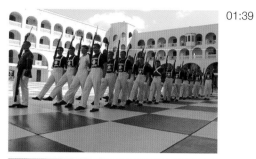

01:39

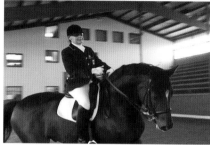

02:12

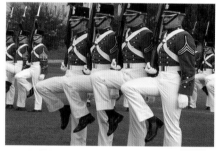

04:17

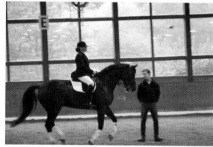

04:55

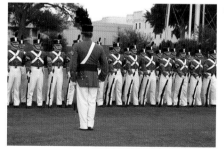

05:34

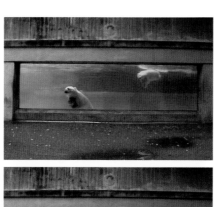

01:24

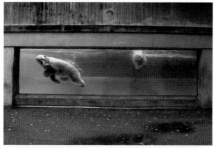

01:31

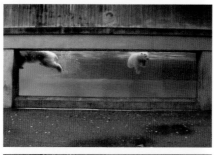

01:36

01:42

01:09

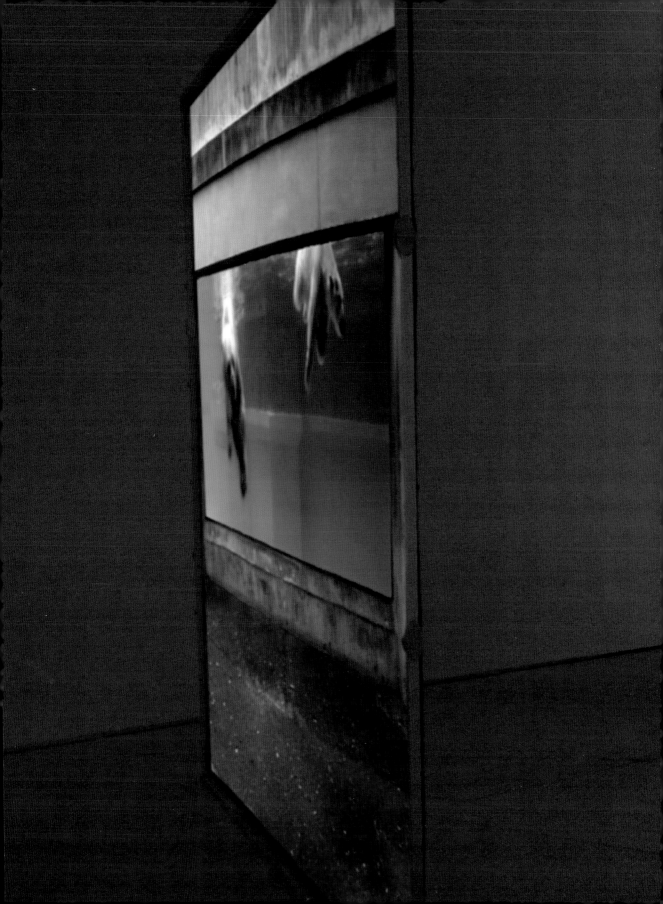

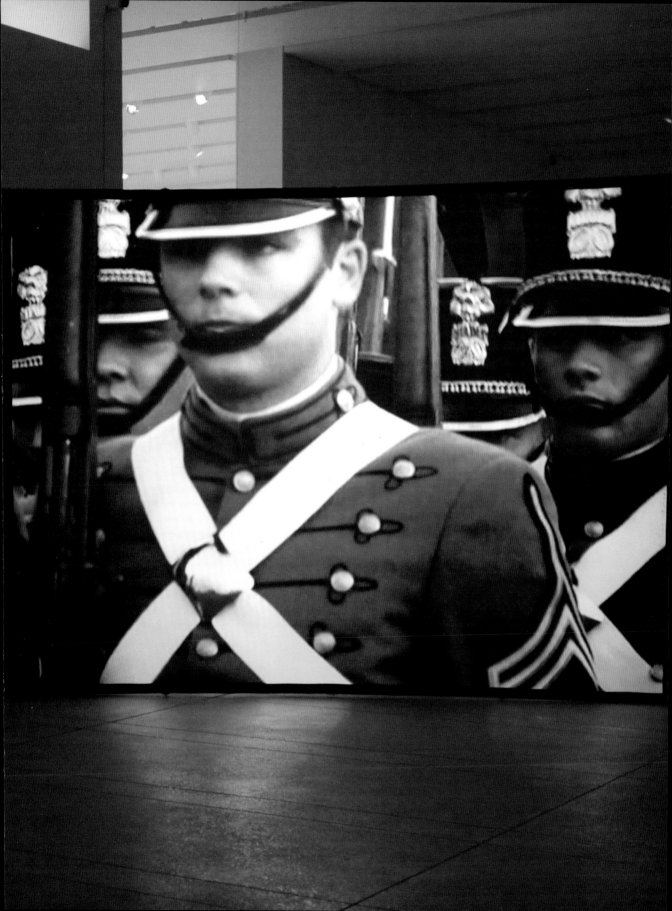

Going Somewhere Fast:
Janet Biggs' *Vanishing Point*

By Andrea Inselmann

Among the videos of athletes and Arctic explorers on view in Janet Biggs' mid-career survey at the Tampa Museum of Art, *Vanishing Point* (2009)—whose subject is a motorcycle speed racer—represents a crossroads of sorts at which many of the thematic and stylistic characteristics of Biggs' work come into sharp relief. The result is a video that, I would say, ultimately engages our deep-seated fascination with moving pictures that began more than 100 years ago, when the earliest films of speeding trains and flying trapeze artists were shown to audiences as hungry for spectacles then as we are today.

One of the important shifts between Biggs' works preceding and following *Vanishing Point* involves the artist's relationship to the physical body. Whereas Biggs' older work tended to revolve around people pushing themselves to their limits and holding almost fanatical control over their own bodies, *Vanishing Point* ushers in a new theme in which Biggs also seeks out the external forces and extreme environments that have the potential to alter her subjects' bodies and to challenge preconceived notions of identity. In these more recent works, even her own body is at risk, as Biggs pushes herself to the extreme to get the shot. She goes from being strapped to the back of a pickup truck racing 105 miles an hour to following a climber into the icy depths of a claustrophobic Arctic cave.

The other shift concerns Biggs' employment of landscape in her videos as it takes on increasingly autonomous roles with the hot desert in *Vanishing Point* and the frozen north in her Arctic trilogy. Landscape becomes a character in its own right, which reflects a development in Biggs' work that pushes far beyond the functional requirements of the settings posed by her stories. Isolating aspects of cinematic structure and insinuating her own presence, Biggs is able to involve her audience emotionally, viscerally, and intellectually, as she creates just enough distance from the work to allow viewers to recognize their own position within the triangulated relationship among video, artist, and spectator.

My first acquaintance with Biggs' work in the 1990s resulted in an exhibition of two of her earliest multiple-screen installations: the 10-channel piece *Girls and Horses* (1996), combining monitors and projections and the two-channel video *Water Training* (1997). At the time, I was particularly struck by Biggs' unconventional representation of female desire and pleasure. Employing the horse as the classic signifier of female sexual sublimation, the exhibition presented an examination of the constructedness of gender, with the two installations enacting a visual dialogue about the relationship between images and women—as both subjects and objects of the gaze, engaging feminist theories about the represen-tation of women and the reception of film texts that were very much part of the broader academic discourse in the 1980s and '90s. The utter abandon of the little girls playing horsey in *Girls and Horses* and the histrionics of the synchronized swimmers in *Water Training* were a form of gender self-construction that

effectively represented women's power to both shore up and tear down traditional notions of femininity. This has remained an important theme in Biggs' work for the past 15 years, as evidenced by the woman coal miner in *Brightness All Around* (2011), the woman speed racer in *Vanishing Point*, the blind dressage rider in *Like Tears in Rain* (2006), and the elderly synchronized swimmers in *Flight* (1999), to mention just a few of the pieces on view in the exhibition.

Not only is a closer look at Biggs' earliest works useful for a better understanding of the origins of her current thematic concerns, it also gives us insight into how and why their structure has essentially remained the same, even though their apparent format may vary from complex multi-channel installations, in which several narrative threads are occurring simultaneously, to single-channel pieces, in which Biggs' editing techniques create similar effects.

With its two images projected across a corner, *Water Training* is a particularly good example of the artist's approach to storytelling. While Biggs' individual image sequences—in both *Water Training* and *Vanishing Point*—seem at first glance related to sports reportage or documentary filmmaking, the way she combines and juxtaposes them is more related to collage, in which she, unlike a documentary filmmaker, can take creative license to make a visual statement. "In this way," Biggs has said, "my work allows a space for viewers to make their own connections, creating a kind of shared authorship with the audience."[1] While this seems obvious in her multi-screen pieces, a similar effect is actually also accomplished through editing in such single-channel pieces as *Vanishing Point*.

Biggs' deceptively simple editing technique—entirely different from traditional Hollywood continuity editing—is rooted in the structure of her first two-channel piece *Water Training*, in which she split the two narrative threads into separate channels, allowing viewers to switch back and forth between the two projections at their own pace, as their role continuously shifts between spectator and performer. The left image shows the head of a horse—eyes glaring and nostrils flaring—strenuously treading water, while the right is a long shot of teenage synchronized swimmers, their heads and legs alternately visible below the surface. This pattern of layering storylines next to or on top of each other is evident throughout Biggs' *oeuvre*, including her multiple-channel video installations such as *Buspar* (1999; included in this exhibition) and *Risperidone* (2001), multimedia performance works such as *Enemy of the Good* (2007) and the most recent *Wet Exit* (2011), as well as Biggs' single-channel pieces that are included in this exhibition, such as *Bright Shiny Objects* (2004), *Duet* (2010), *Fade to White* (2010), and *Vanishing Point*, in which Biggs uses this technique to maximum effect.

In *Vanishing Point*, Biggs employs her alternating narrative format in 10½ fast-moving, adrenalin-producing minutes to pair two seemingly unrelated stories: motorcycle racer Leslie Porterfield, trying to set a speed record on Utah's Bonneville Salt Flats and Harlem's Addicts Rehabilitation Center Gospel Choir, performing a song that was written by the artist herself. Biggs took the title for her video from Richard Sarafian's 1971 cult road movie, a product of its time very much like the original counterculture epic, *Easy Rider* (1969). This nod to Hollywood genre films is not new in Biggs' work. Already in *Water Training*, Biggs had tapped into our collective cinematic image bank when she took up synchronized swimming as a subject that would make an appearance again and again in her videos over a

ten year period, essentially becoming a thematic and stylistic trademark of her work. Overly stylized and, by contemporary standards, campy and over-the-top, Biggs herself has made reference to "the Busby Berkeley, drag-queen-like quality," that attracted her to this highly athletic sport, in which "a tremendous amount of effort is spent to create the impression of effortlessness,"[2] a misrepresentation directly related to the efforts of gender construction in Hollywood films. It wasn't only Berkeley's lavish musicals that presented this heightened sense of masquerade to a female audience in the 1930s and '40s. Melodrama, which personalized the psychological tension between female desire and socially endorsed femininity, eliciting highly emotional responses, was of interest to Biggs as well. *Water Training* reads against the grain of these historical film genres, in which the symbols of excess in the affected behavior of the synchronized swimmers readily evoke cultural theorist Judith Butler's performative theory of gender, as I argued in my original discussion of *Water Training*:

> *Water Training* pairs this performance of femininity with an image of a single "masculine" horse struggling to stay afloat. The close-up of the horse's head above water—his veins and muscles visibly taut—generates empathetic discomfort in the viewer. We are witnessing something that is usually concealed, which, therefore, activates the myth of natural strength in both horses and men. Just as Biggs chooses to focus on the swimmers' intense efforts below the surface to produce a stereotypical image of feminine grace above the surface, she represents the classical symbol of masculinity in training and therefore in crisis … the horse is a signifying mark of feminine pleasure or masquerading masculinity, two sides of the coin in the construction of gender. This interdependency in the staging of gender also emerges from Biggs' decision to project the images in *Water Training* next to each other, such that the corner itself functions as a visible suture, replacing the invisible editing of dominant cinema and its hidden gender constraints.[3]

Structuring *Water Training* in this way allowed Biggs to avoid the narrative conventions of documentary-style filmmaking, exposing hidden agendas related to notions of identity, a technique that she uses in her single-channel pieces as well, which make up a more and more significant portion of her recent work.

Being an artist of the post-cinematic era, however, Biggs is not only interested in questioning our relationship to motion pictures, but also in exploiting the seductive power of those images to her own ends. Having an understanding of cinema as repository of visual raw material that floods the broader global culture, Biggs wants to expose it as a constructed spectacle by referencing generic conventions, such as Hollywood musicals and melodrama in the case of *Water Training*. As such, she redirects attention to the requirements of the medium itself and makes the position of the spectator one of her topics, thus unraveling the illusionary effects of commercial films. Biggs' project in *Water Training* and *Vanishing Point* is in this way related to the projects of such artists as Stan Douglas, Douglas Gordon, Candice Breitz, and Pierre Huyghe, whose methods of quoting, paraphrasing, dissecting, and imitating the repertoire of cinema are designed to challenge the audience's routine expectations of film texts. Many of these artists "re-make" iconic pieces of film history by using found footage. This technique tends to be more alienating to viewers, as it introduces a conceptual approach to the source material that often results in pieces that are more interesting to read about than

to actually watch. For instance, in *24 Hour Psycho* (1993), Douglas Gordon de-celerated Alfred Hitchcock's 1960 classic *Psycho* to stretch over a literal 24 hours, dissolving the original's psychological tension generated via narrative, cinema-tography, and soundtrack, utterly frustrating viewers' payoff at the end. Pierre Huyghe's *The Third Memory* (1999) re-creates the true-life bank robbery featured in Sidney Lumet's *Dog Day Afternoon* (1975) with the real bank robber (after his release from prison), demonstrating cinema's capacity to distort and ultimately shape memory. While Biggs doesn't engage her source material in these same ways, she does exploit its structure by selecting individual thematic elements to reinforce her argument. While the intercutting between the speed racer and the choir in *Vanishing Point* is based on the format of the original Sarafian film, which also alternates between two narrative strands that are connected in the most implausible and tenuous ways, Biggs' video is a direct result of techniques she began to develop in two-channel pieces such as *Water Training* as well.

Biggs is fully aware of cinema's effects and the medium's complicated relationship between fact and fiction. She is, however, also attracted to cinema's affective qualities to seduce and create a visceral response in her viewers. In order to attain such effects, Biggs draws on professional editing techniques and high production values, endeavoring to draw the viewer in both visually and acoustically, noting, that she is "interested in a certain kind of initial seduction … So there's a kind of 'formal' quality to the work that allows the viewers to enter. And once there's a level of commitment in terms of the audience giving over to the piece … I can go more interesting places in terms of conceptual underpinnings of the work."[4]

Straddling the two general approaches to the cinematic experience among contemporary artists—one affective and the other more conceptual—Biggs creates videos in a style that is related to the approach to the medium of Finnish artist Salla Tykkä, who is best known for the trilogy *Cave* (2003), in which she uses recognizable musical scores to quote such sensationalist Hollywood genres as the horror, Western, and science fiction film, demonstrating a keen understanding of their identity politics as expressed in tightly organized systems of looks and identification.

Tykkä's *Lasso* (2000), which is the second film of the trilogy, opens with a young woman approaching a large picture window of a suburban Helsinki house as the affecting title track from Sergio Leone's Spaghetti Western, *Once Upon a Time in the West*, sets in. A careful reading of Tykkä's video demonstrates that she not only appropriated the title track of Leone's Western but his camera work as well. Tykkä subverts the quintessential grammar of this genre to create a gender fluidity in her video that, structured around a set of intense close-up gazes and highly choreographed scenes, breaks down conventional identificatory patterns, which is very much reminiscent of Biggs' way of working.

Deploying Hollywood allusions in a similarly strategic way, Biggs' reference points in *Vanishing Point* also come from genres conventionally considered masculine, such as the Western and the road movie. Sarafian's original movie starred Barry Newman as a car delivery driver named Kowalski. A decorated Vietnam veteran and a former race car driver and motorcycle racer who had two near-fatal accidents, we learn in flashbacks throughout the movie that Kowalski lost everything he ever wanted, including his job as a police officer and the love of his life. Filmed on

location throughout the Southwest and including views of "open endless land-scapes"[5] that were of particular interest to Biggs for their contribution to the movie's "existential themes,"[6] the narrative follows Kowalski driving a white Dodge Challenger muscle car in a high-speed chase, racing the Nevada and California State Highway Patrol on his way from Denver toward San Francisco. The cops chase him through some of the most scenic states of the American West, but they never catch him. During the entire 35 hours of the chase, Kowalski's car radio is tuned to KOW, broadcasting out of Goldfield, Nevada, where a blind African-American DJ known as Super Soul encourages him to escape from the police and calls him "the last American hero," making Kowalski a symbol of the post-Woodstock, disillusioned hippie and biker counterculture of the early 1970s. Kowalski's existential attempt to escape the world finds its conclusion in the *Thelma and Louise*-like ending of the movie, when he decides to crash into two bulldozers that were set up by the police as a roadblock. Exhibiting almost mystical qualities, the movie ends with light gleaming between the blades of the bulldozers as Kowalski, with a smile on his face, races to his death, which we, of course, never witness, suggesting the protagonist's total control of his own destiny.

In Biggs' version, more than the title is similar to the original *Vanishing Point*, whose structure of intercutting Kowalski's chase with scenes of Super Soul's radio station is, as I mentioned, evoked by Biggs' alternating narrative format, switching between scenes of Porterfield on the Salt Flats and the choir in Harlem. Other similarities become apparent as well, such as Biggs' handling of the opening music track for her video. She instructed John Collins, the composer of the opening guitar score, to keep it similar in feeling to the original movie's intro music, asking for it to lead into the gospel song that the Addicts Rehabilitation Center Gospel Choir performs: "I wanted that feeling of slowly gathering to witness something, the waiting and expectation."[7] While the guitar music sets a mood of anticipation in the video, we watch spectators—most of them middle-aged men, some of them with binoculars—looking into the distance, just like in the original *Vanishing Point*, where onlookers are waiting for Kowalski to drive up to the road block. The opening scene, with the flag flapping in the wind, is eerily reminiscent of the shot of the bulldozers set up in the road in the 1971 movie. "And, as in the classic Western," Nancy Princenthal observed, "the protagonist in Biggs' *Vanishing Point* is introduced in a shot that shows her straddling her motorcycle as if she were astride a horse. The ominous deliberation of this move is enhanced by a slight slowing of the action, and by the extremely low angle of the shot, which greatly magnifies the subject's physical presence (and leaves her head out of the frame)—a pair of devices also derived from genre films."[8] Building tension and anticipation, Biggs tweaks mainstream filmmaking tools just enough toward her own ends, as she activates our complete enthrallment with the medium through images and sounds of speed, danger, and atonement.

While the 1971 version combines the thrill of speed and psychedelic drugs in the main character of Kowalski, Biggs has teased these two strands apart in her version: one narrative track focuses on Porterfield, who, having survived serious injuries on the salt flats in 2007, returned one year later to break her own record-setting speed by reaching 234 miles per hour. The other takes place at Harlem's Addicts Rehabilitation Center, where a group of African-American men and women of varying ages perform Biggs' song about "fading away" and "speeding towards that vanishing point." Both sequences are about addiction and control

over one's own life and are, in this way, very much related to other works that Biggs has created about the slippage involved in the formation and preservation of identity. But there is also a double meaning hinted at in Biggs' title, which goes beyond the central definition of "vanishing point" in the Western representational system, as the point at which all imaginary lines of perspective converge.

Biggs' video includes three racing sequences with Porterfield shot in different ways. In the first, we watch and listen to the motorbike speeding away into the distance until we cannot make it out anymore in the glistening heat over the huge expanse of slippery salt. For the second and longest scene, the camera, i.e., Biggs, travels alongside Porterfield in unnerving silence until the camera falls behind and we watch the racer once again disappear into the void. The most exhilarating sequence in the video, however, is shot from a camera mounted on the front of the motorcycle, giving us, the viewers, a front row seat to the thrilling speed race. The unbearably loud noise of the engine and the vibration of the bike speeding over the bumpy surface make us imagine being the racers ourselves. But as the screen goes black abruptly, we are brought back to another kind of awareness: "the other side of risk," to use Biggs' words, where "vanishing point" refers to the place where one disappears or ceases to exist, like Cliff Gullett, whom Biggs was filming the day before he lost his life on the Salt Flats that summer and to whom she dedicated *Vanishing Point*. I would subscribe to the view that the actual meaning of Biggs' work lies within the intense black at the end of her film. That it lies within the seemingly blank wide-open space delimited within her filmic construction. I would say that the work is that which is neither seen nor heard. That which becomes conspicuous through its absence, like death itself. Which, I would submit, constitutes the allure of moving pictures for us in the first place.

Andrea Inselmann has been curator of modern and contemporary art at the Herbert F. Johnson Museum at Cornell University since 2002, where she has curated many solo and group exhibitions of national and international artists, both established and emerging. Prior to her current appointment, she has held curatorial positions at the Kohler Arts Center, the Harry Ransom Humanities Research Center at the University of Texas, and the Whitney Museum of American Art. She has curated dozens of exhibitions and is the author of such publications as A Second Look: Women Photographers from the Gernsheim Collection *and* stop look.listen: an exhibition of video works.

[1] Janet Biggs in an interview with Terry Ward on Grumpyvisualartist Art Blog (http://grumpyvisualartist.blogspot.com/2010/12/blog-post_6119.html), 2.

[2] Janet Biggs as quoted by Nancy Princenthal in *VantagePoint IX Janet Biggs: Going to Extremes* (Charlotte, NC: Mint Museum, 2010), no page numbers.

[3] In my initial discussion of *Water Training* in *Up Downs: Janet Biggs* (Sheboygan: John Michael Kohler Arts Center, 1999), I quoted Judith Butler, whose writings Biggs has referred to herself, "[t]here is no gender identity behind the expressions of gender . . . identity is performatively constituted by the very 'expressions' that are said to be its results." *Gender Trouble: Feminism and the Subversion of Identity* (New York and London: Routledge, 1990), 25.

[4] Biggs, in an interview with Terry Ward, ibid., 12.

[5] This and all other subsequent quotes by the artist are from an e-mail exchange with the author, August 16-23, 2011.

[6] Ibid.

[7] Ibid.

[8] Nancy Princenthal in *VantagePoint IX Janet Biggs: Going to Extremes* (Charlotte, NC: Mint Museum, 2010), no page numbers.

Vanishing Point, 2009

Single-channel, high
definition video with
sound, 16:9 format.

Running time:
00:10:32.

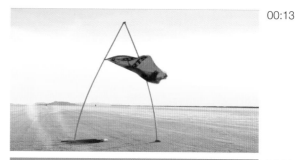

00:13

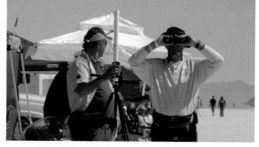

00:30

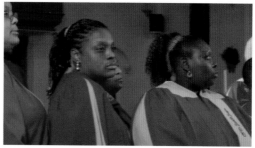

01:03

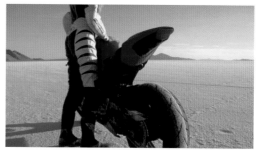

1:16

01:25

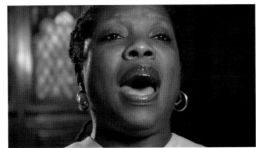 03:02

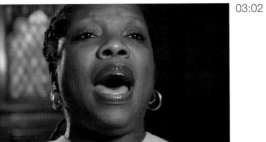 03:19

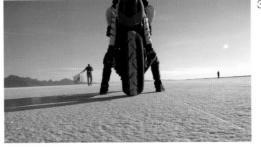 3:59

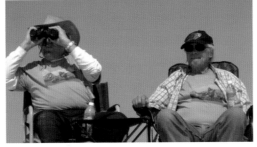 04:50

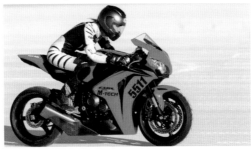 06:18

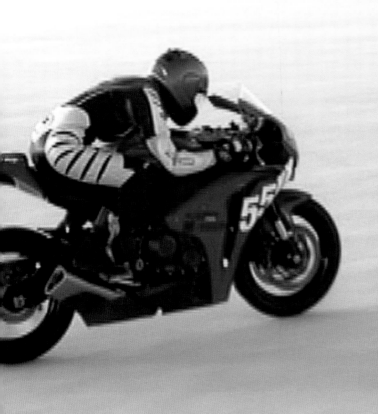

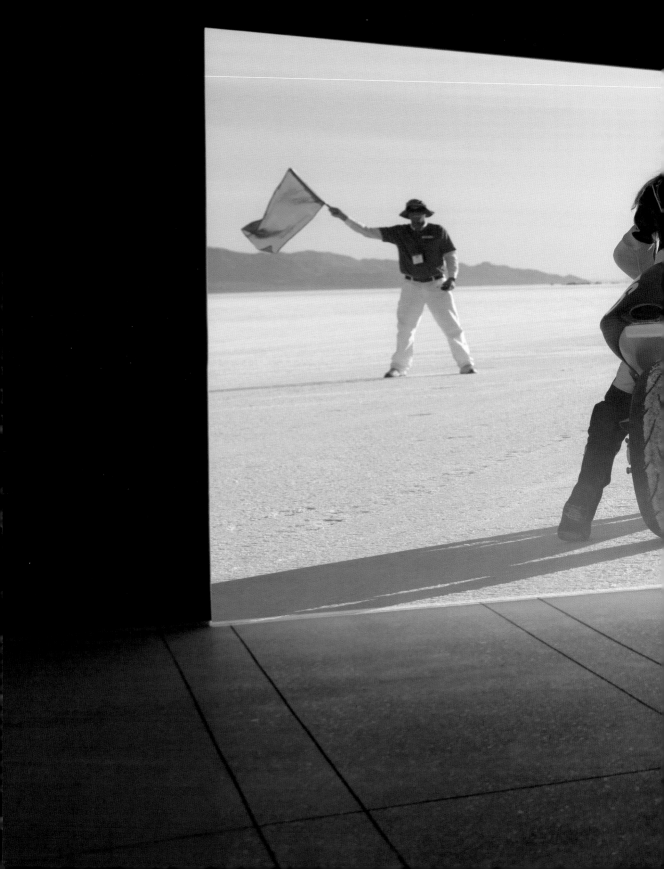

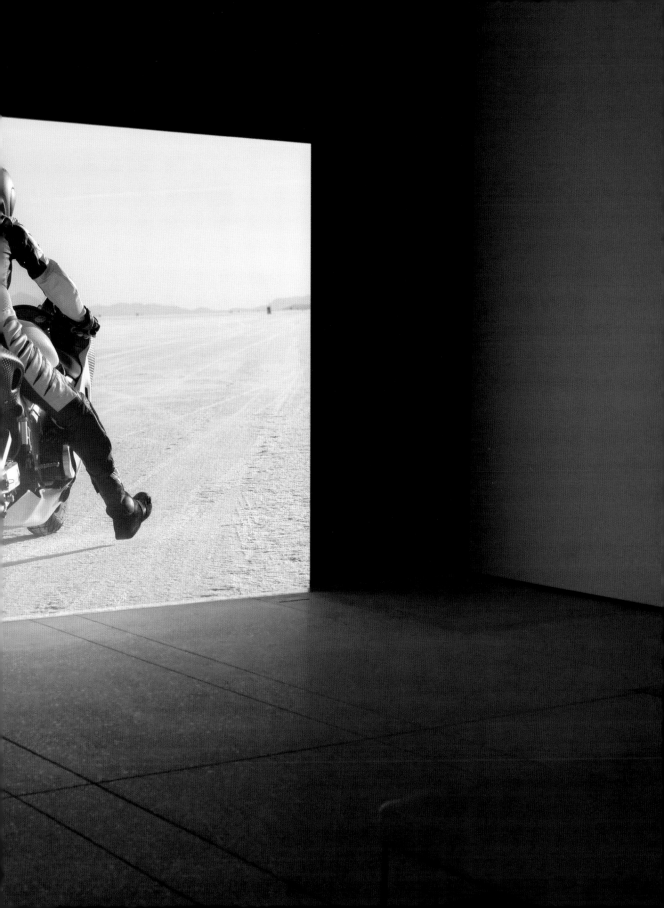

Duet, 2010

Single-channel, high definition video with sound, 16:9 format.

Running time: 00:06:47.

00:10

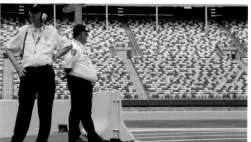
00:26

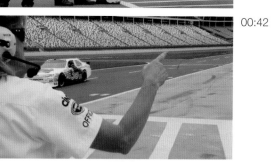
00:42

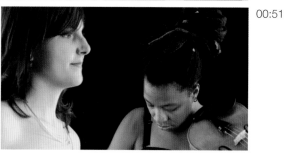
00:51

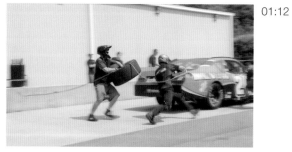
01:12

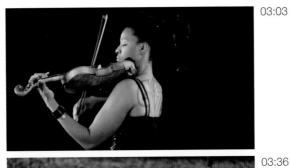 03:03

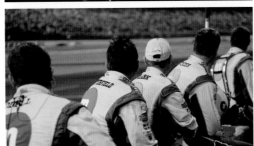 03:36

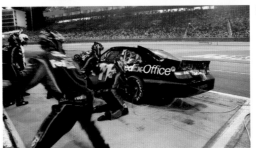 03:52

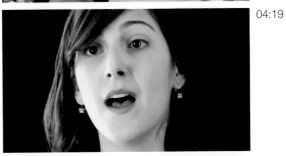 04:19

 05:02

Janet Biggs: Mining the North

By Nancy Princenthal

"To say 'we leave for the north tonight' brings immediate thoughts of a harder place, a place of dearth," writes Peter Davidson in *The Idea of North*.[1] "A good part of the understanding of North, throughout the world, is bound up with melancholy and remoteness."[2] In ancient and medieval thought, the North—*the ultima Thule*—was associated with lawless hordes and hyperborean demons. The deepest rung in Dante's *Inferno* is icy, and darkened by frosty mist. Mary Shelley's *Frankenstein* opens on a boat sailing the seas north of Russia, in search of a northwest passage. The famous monster is first seen being pulled by sled dogs across "vast and irregular plains of ice;" the novel ends where it began, shipboard on an ice-bound northern sea.

At the same time, suggests Romantic literature, and painting as well (see again Shelley or Caspar David Friedrich), there is no surpassing the Arctic's sublimity, its compound of exalting peril, and visual purity. As described in 1897 by the Norwegian explorer Fridtjof Nansen, "Nothing more wonderfully beautiful can exist than the Arctic night. It is dreamland, painted in the imagination's most delicate tints; it is color etherealized. One shade melts into the other … I have never been able to grasp the fact that this earth will some day be spent and desolate and empty. To what end, in that case, all this beauty, with not a creature to rejoice in it? Now I begin to divine it. *This* is the coming earth—here are beauty and death."[3]

The promise of beauty and the immanence of mortal danger are surely among the things that drew Janet Biggs to Svalbard, a group of islands off the coast of Norway that she visited in 2009 and 2010 aboard the century-old schooner *Noorderlicht*, along with a handful of scientists, other artists, and the boat's crew. But the three videos she made there demonstrate that she has become progressively leery of the Arctic's romance. Biggs' most recent works are concerned with other characteristics of the Polar north, starting with the elusiveness of its cardinal points. Space and time are both warped there; extreme changes of state in physical substances—of liquid to solid, solid to vapor—are the rule rather than the exception; vision is unreliable, subject to misperceptions and outright failure. In short, the mind boggles.

Fade to White (2010) begins Biggs' northern trilogy. Of the three videos, it is the most lyrical and portrays the landscape as least easily penetrated. It opens with a solitary man, the guide Audun Tholfsen, bundled against the audible wind and peering through a pair of binoculars, which silently announce the challenge of bringing the great, bleak vista before him into focus. As in previous works by Biggs, footage documenting a mute feat of courage and strength—Tholfsen's navigation of the icy and sometimes turbulent waters in a slender and fragile-seeming kayak (unseen, Biggs is paddling nearby)—alternates with that of a volubly expressive musical performance; a tense opposition is thereby established between emotional and physical risk-taking. In *Fade to White,* the musician is the remarkable countertenor John Kelly, who sings a deeply haunting Baroque aria.

Several other conditions that will recur in the succeeding videos are introduced in *Fade to White*: color fades in the predominant gloom; sunlight is scarce and precious. Horizons tilt and blur; orientation is difficult. The sea thickens to unfamiliar consistencies neither watery nor glacial. Breath becomes smoke, tensile and pliable things become brittle. And animate beings, including a few polar bears that appear at the end of the video as well as occasional birds, are dwarfed. The scant on-screen humans seem, here and in succeeding works, particularly negligible.

The Arctic is a place of paradox and contradiction; there are actually two poles at its center, one geographic and the other magnetic. The magnetic terminal, at present a south pole in terms of its charge, is no more a physical place than is the geographic one, but merely the topmost point of the earth's magnetic field (which periodically flips its orientation). At the northern end of the world, compasses don't do much good. As Davidson notes, "Direction is suspended at the North and South Poles; they are places outside place."[4] Since the world's time zones all meet there, the poles also play havoc with temporal measurement. They are points of abstraction—and crucial parameters for Biggs' Arctic videos.

The consequences of the region's climate, however, are all too real. We are also made aware, in Biggs' work, that under Arctic conditions flesh could freeze and break like glass; exposure is peril and concealment a basic form of self-preservation. The conclusion of the first Svalbard video, with its titular fade to white, reminds us that Arctic light is often capricious, producing mirages and spectacles (the Northern Lights) as well as optical incapacitation (when bouncing off snow). Most implacably, light regularly disappears altogether, in the months-long winter night. Moreover, scale is skewed in the far north. If humans seem overwhelmed there by the land-scape's unbroken expanses, the region's truncated growing seasons produce flora and fauna of monstrous sizes (giant insects, enormous flowers). Through Biggs' lens, the planet is experienced as an object, and also as a force. Invited or not, sublimity happens.

In an essay on "The Gigantic," the poet Susan Stewart lists the constituent qualities of Edmund Burke's famous classification "the sublime" as "obscurity, power, privations, vastness, infinity, difficulty (requiring vast expenditures of labor and effort), and magnificence." Reflecting on Burke's legacy, Stewart makes an important clarification: "What distinguishes the sublime from the beautiful is that the former is individual and painful, while the second is social and pleasant."[5] Clearly, Biggs' vision in *Fade to White*, as in her other Arctic videos, is neither social nor pleasant. "The Gigantic" appears in Stewart's book *On Longing*, which in many ways parallels Gaston Bachelard's landmark book, *The Poetics of Space*. Bachelard's chapter on "Intimate Immensity" begins, "One might say that immensity is a philosophical category of daydream," and goes on to evoke "a region of the purest sort of phenomenology—a phenomenology without phenomena."[6] Somewhere between the privations and difficulty of Stewart's sublimity and the dreaminess of Bachelard's immensity lies the territory of Biggs' Arctic.

Bachelard's meditations lead him to distinguish the scale of forests from that of fields. One can't get lost in fields, he wrote, but forests are immense, and one can enter them deeply—indeed too deeply, as with an ocean. This confusion between lateral extent (immensity) and depth (a vertical measure) is given form in Biggs' next two videos. *In the Cold Edge* (2010) (its title is a translation of Svalbard), takes

us under the surface of the ice. The soundtrack begins, as does *Fade to White*'s, with wind; the rasp of pick against ice soon follows. The protagonist this time is an ice-cave spelunker, Andreas Eriksson, who enters a series of fantastic underground ice chambers so narrow that he is forced at one point to crawl on his stomach. The only light comes from a lamp strapped to his helmet—and a second lamp that is the artist's. Behind her camera, Biggs is following close behind, and sharing the cave's manifest dangers. An electronic drumbeat emerges from beneath the ambient sound, and then an ominous clock-like ticking; as darkness gives way to a glimpse of daylight overhead, strings are introduced, and the music grows more buoyant. (It is by Blake Fleming, and mostly expresses both the hazardous, claustrophobia-inducing conditions of the cave—and, Biggs says, "the wonder of being somewhere no one else had been.") But Eriksson's emergence from underground into waning light is not triumphant, and the video's strongest sensation is of isolation—despite the implied presence of the unseen artist—and vulnerability.

In the Cold Edge concludes in a wind-wracked, frigid landscape, where Biggs, almost lost in her parka and hat, loads a gun, aims it point blank at the camera, and then turns and fires it across an expanse of frozen water. It produces a breath-taking streak of luminous red against the unrelentingly grim sky. Directing the camera into the muzzle of a gun is of course a melodramatic gesture, but Biggs seems less interested in turning the viewer, momentarily, into a victim than in manipulating orientation and sight lines. The video's progress, from the surface of the landscape to its labyrinthine depths and back, ends by reestablishing its vast horizontal sweep with the streaking red flare. In any case, the danger is not in the flare gun but in the landscape itself, which is heedless of intruders. At the video's end, a small, lone figure—Biggs—is seen over-matched by mountains and ice.

Or, arguably, the reverse. In a review for *The New York Times*, Holland Cotter wrote that the flare at the end of *In the Cold Edge* "implies a condition of emergency," perhaps to do with the fate of "the Arctic's fragile ecosystem."[7] Biggs is far from insensitive to the threats the region faces, which are indisputably grave. Environmentalist and frequent *New Yorker* contributor Elizabeth Kolbert writes that while average global temperatures have risen (as of 2007) by about one degree Fahrenheit, in the Arctic they have gone up roughly twice that amount. "Current forecasts suggest," she says, "that a Northwest Passage could be ice-free, at least in summer, by 2025. The North Pole itself could be open water in summer by 2050."[8] These dire facts are among the conditions that give Biggs' work its undeniable pathos. But the tunneling under and shooting across that structure *In the Cold Edge* suggest concerns more emotional and phenomenological than ecopolitical.

Again, there is a relevant literary heritage. In Jules Verne's *Journey to the Center of the Earth*, access is through a (fictional) Icelandic volcano, its crater 5,000 feet high. After encountering an "optical illusion common in the mountains" by whose lights the rapturous icy peaks "appeared remarkably close," Verne's explorers face intoxicating voids, abundant underground water, noxious gases and prehistoric animals; along the way, their compass is disabled. The 1864 novel has only oblique relevance to Biggs' Arctic videos, however striking is the formal parallel of travelling across the planet's northern limits in order to descend beneath its skin.

In the Cold Edge can also be compared, perhaps less incidentally, to Matthew Barney's video *Cremaster 4* (1994); shot on the Isle of Man, it follows its tap-dancing and motorcycle-riding protagonists in a dizzying circuit around and under the island's surface. Also relevant is Mika Rottenberg's *Squeeze* (2010), which tunnels through both physically carpentered and digitally simulated wormholes from fields to factories, nail salons to meditation chambers; throughout, signposts for up, down and sideways shift vertiginously. Biggs has herself explored this trope before, notably in *Airs Above the Ground* (2007), which features an underwater dancer who performs with her head pointing toward the swimming pool's floor; screened upside down, the video reverses the performer's inversion, creating a powerful experience of disorientation. Similarly inverted underwater dancers also appear in Biggs' *Bright Shiny Objects* (2004), and in *Flight* (1999), where the swimmer is paired with the voice and brief image of an astronaut in space. Not simply a metaphor—that is, not a simple sign for an emotional state—the spatial confusion is, for Biggs, also itself the subject; in the Arctic videos, it is elemental and progressive.

In the Cold Edge is a fairly short video, and a solo performance, in the sense that no on-screen musician alternates with its central protagonist. The final work in the trilogy, *Brightness All Around* (2011) returns to the format of call and response, while also enlarging on other motifs that appear in the preceding works. Again, it opens with a bleak, frigid landscape and the sound of wind. Next, we see dozens of heavy boots on racks. Utilitarian and uniform, they make a striking comparison with the working gear of Bill Coleman, a musician who is first seen being prepped for his performance—as he loosens his shoulders, his face is brushed with cosmetics (as was that of the swimmer in the opening scenes of *Airs Above the Ground*). Like John Kelly in *Fade to White*, Coleman is a little androgynous, but while Kelly is dressed in white and his face lightly powdered, Coleman wears a demonic black leather outfit, including a knee-length leather apron. By contrast, Linda Norberg, the coal miner featured in *Brightness All Around*, suits up in a safety-orange vest with reflective silver stripes. A preliminary beat of music, and then the answering drumming of machines as Norberg faces the tunnel's gaping black mouth, introduce the punning connection between two different kinds of hard rock.

Coleman's music follows Norberg into the mine, which is in Svea, a brutally isolated, roadless community reachable only by a small prop plane generally restricted to miners (an exception was made for Biggs, an irresistible problem-solver). The tunnel descends for miles, an improbably long distance that is covered fast, as in a spooky fun-house ride but with even less clarity as to direction. Along with a helmet-mounted headlight that, in this context, gives her the aspect of some fantastic deep-sea fish, Norberg wears big earphones. Presumably they muffle the noise of the mine's equipment, although it appears she's listening to the same sensual, pounding musical soundtrack we are. Echoing previous videos, *Brightness All Around* cuts back and forth between Coleman, a lithe and muscular performer, and Norberg, whose descent into the tunnel is rendered the more sexual by the juxtaposition. Like Leslie Porterfield, the motorcycle racer featured in Biggs' *Vanishing Point*, Norberg is beautiful, although her face is more weathered and angular; to risk bludgeoning the same pun, she is a kind of rock star. An eight-year veteran at Svea, she excels at one of the mine's most dangerous jobs, bolting the ceilings of newly cut shafts.

And stardom, with its narcissism and its real risks, is definitely at issue in this work. "I looked down and I saw myself," Coleman sings over and over, as bright back-lighting creates a nimbus around him. At a climactic point, his eyes roll back, a moment that strikingly invokes religious transport. In alternation, we see Norberg, alone, operating formidably big and heavy machinery. Then Coleman sings the titular phrase, "There was brightness all around," while gyrating with furious energy and ultimately inverting himself in a full back bend. (Although she doesn't make this explicit in the work itself, it comes as no surprise that all the lyrics, written by Biggs, derive from accounts of near-death experiences she collected from inter-views and online.) As the video ends, Norberg is shot against rapturous light at the tunnel's exit; like Audun Tholfsen in the first work of the trilogy, she fades to white in the final scene.

The physical risks taken by subject and artist alike are less of the elemental man-against-nature variety in *Brightness All Around* than in the two previous Arctic videos, since the dangers are those of human endeavor—heavy industry—and only equivocally elective. (Norberg is doing this to make a living, not for sport). And the Polar landscape is less enthralling in this video than in its two Arctic predecessors; instead, thralldom is itself put in question. With this trilogy, and especially its last work, Biggs has entered the territory of self-consciously extreme tourism also occupied by Robert Smithson, the more so as Biggs' most recent project, like her last, involves mining—in the fall of 2011, she went to an open-pit sulfur mine at the Ijen volcano crater in East Java, Indonesia, where fairly horrific working conditions prevail. (It is tempting to add that nineteenth century travelers, perhaps influenced by tales of the infernal north, reported seeing sulfurous flames of many colors licking up from beneath Siberia's frozen earth.[9])

Smithson was notable, among Earthwork artists of his generation, for his attraction to disused industrial sites, including abandoned mines, toward which he turned with particular attention at the end of his short career. Travelling both to physically and culturally exotic places (the Yucatan), and to near, prosaic ones—Passaic, New Jersey, very close to where he grew up—Smithson found ironic connections between their artifacts. His famous mock travelogue, "A Tour of the Monuments of Passaic, New Jersey" (1967), begins with a fake-scholarly observation of a bridge over the Passaic River; the central portion of the bridge rotates to allow passage for a barge carrying "unknown" contents, the western end of the truncated span facing south and the eastern end north. Describing this first false mystery, Smithson's straight-faced account of lumbering disorientation concludes, "One could refer to this bridge as the 'Monument of Dislocated Directions.'"[10] The echoes in Biggs' work are resonant.

Strikingly, Smithson also points, in this essay, to the construction of New Jersey's new highway, as did Michael Fried in his landmark 1967 essay "Art and Object-hood;" Fried was himself citing a trip Tony Smith made on the unfinished highway, and wrote about; Smith connected its scale to a Nazi drill ground at Nuremberg.[11] The portentousness that artists (and critics) saw in the new interstate highway system, in the 1960s, has a striking parallel with the subsequent cultural response to the advent of the Internet and the contraction of both temporal and spatial distances it has brought about. The burgeoning network of high-speed interstate highways is a symbol for the kind of global travel and communication that Smithson

presciently understood would come to shape a great deal of art in the decades to come. It has certainly played a role in Biggs' work.

While Biggs' sensibility is at odds with Smithson's dark humor, and admits a far wider emotional range, she similarly guards against the Romantic sentimentality that has so forcefully shaped cultural perception of challenging environments and the exertions they demand. Early in her career, Biggs made videos that considered states of mind altered by illness, and by both compulsory and voluntary consumption of drugs. She was also deeply interested in physical discipline and its relationship to art, an interest she maintains. In her recent work, she continues to examine the reciprocal pressures exerted by implacable physical conditions, political and economic forces, and the sometimes astounding strength of sheer will.

Nancy Princenthal is a New York-based writer and former Senior Editor of Art in America. *She has contributed to publications including* Artforum, Art News, Parkett, the Village Voice, *and* The New York Times. *Her monograph on Hannah Wilke was published by Prestel in 2010.*

[1]Peter Davidson, *The Idea of North*, (London: Reaktion Books, 2005) p. 9

[2]Davidson, p. 17

[3]Fridtjof Nansen, "The Winter Night," in Elizabeth Kolbert, editor, *The Ends of the Earth: An Anthology of the Finest Writing on the Arctic* (New York: Bloomsbury, 2007), p. 48

[4]Davidson, p. 13

[5]Stewart, "The Gigantic," *On Longing: Narratives of the Miniature, the Gigantic, the Souvenir, the Collection* (Durham and London: Duke University Press, 1993), p. 75

[6]Gaston Bachelard, "Intimate Immensity," *The Poetics of Space* (Boston: Beacon Press, 1969), pp. 183-84

[7]Holland Cotter, "Janet Biggs: 'The Arctic Trilogy,'" *New York Times*, February 17, 2011, accessed online at www.nytimes.com

[8]Kolbert, Introduction, *The Ends of the Earth*, p. 5

[9]Davidson, p. 47

[10]Robert Smithson, "A Tour of the Monuments of Passaic, New Jersey," *The Writings of Robert Smithson*, Nancy Holt, editor (New York: New York University Press, 1979), p. 53

[11]Michael Fried, "Art and Objecthood," in *Minimal Art: A Critical Anthology*, Gregory Battcock, editor (New York: Dutton, 1968), pp. 130-31

Fade to White, 2010

Single-channel, high
definition video with
sound, 16:9 format.

Running time:
00:12:28.

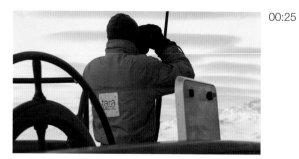
00:25

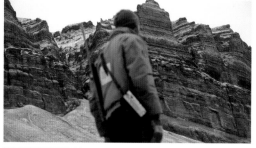
00:55

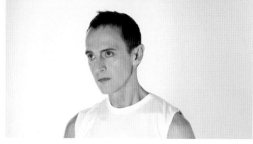
01:10

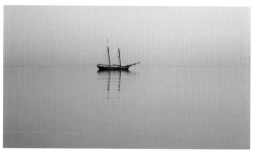
01:52

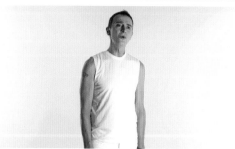
01:58

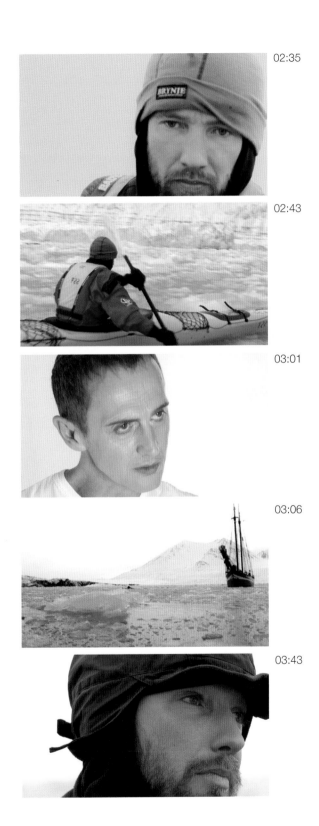

02:35

02:43

03:01

03:06

03:43

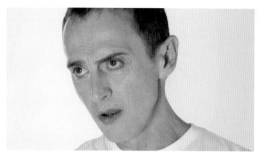 05:40

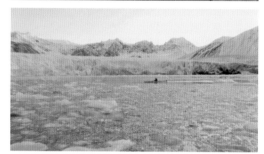 06:00

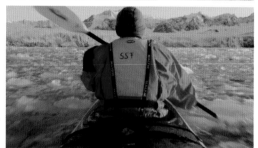 06:05

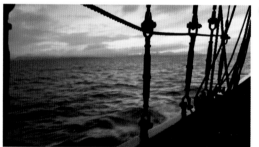 06:16

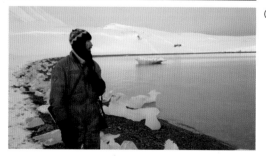 06:25

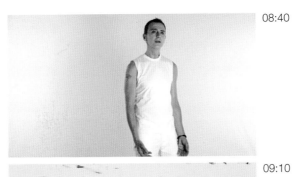 08:40

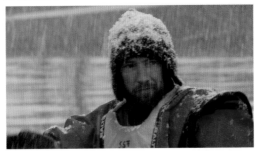 09:10

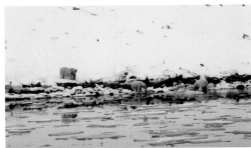 10:10

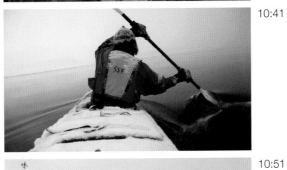 10:41

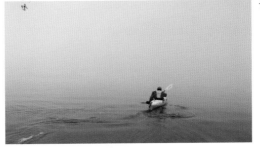 10:51

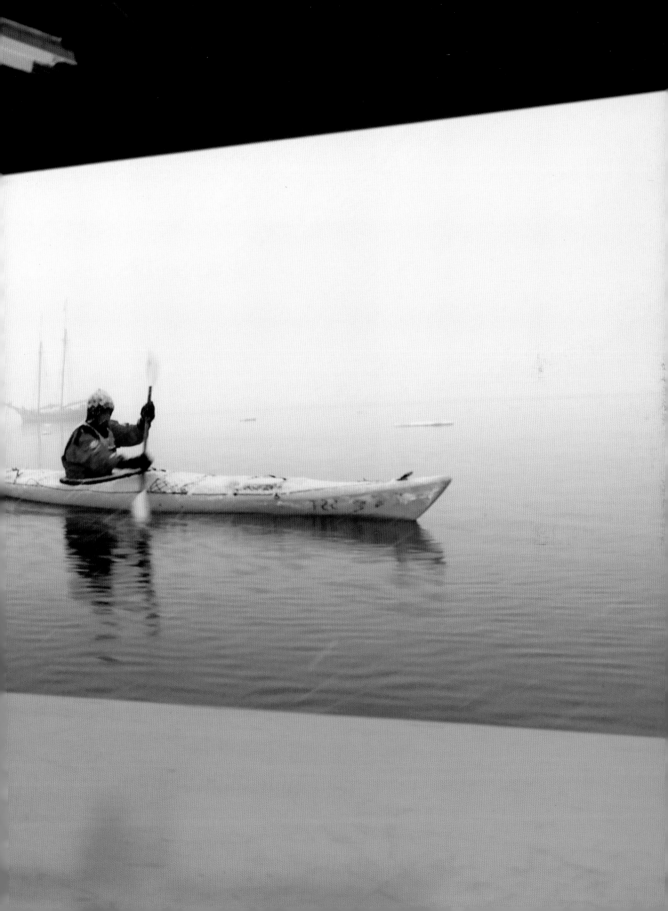

In the Cold Edge, 2010

Single-channel, high definition
video with sound, 16:9 format.

Running time:
00:05:29.

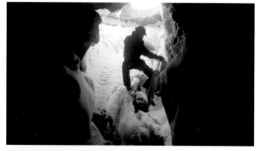

00:31

01:21

02:11

03:21

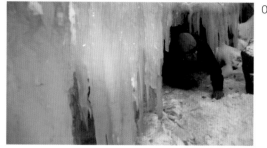

04:07

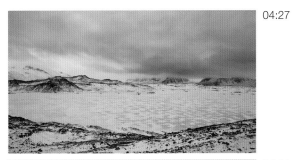

04:27

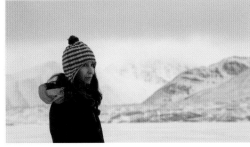
04:32

04:34

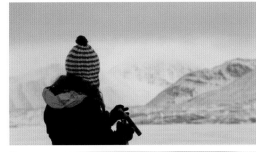
04:53

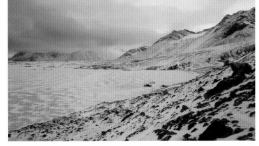
04:55

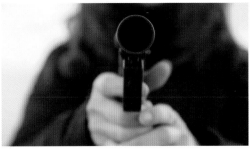

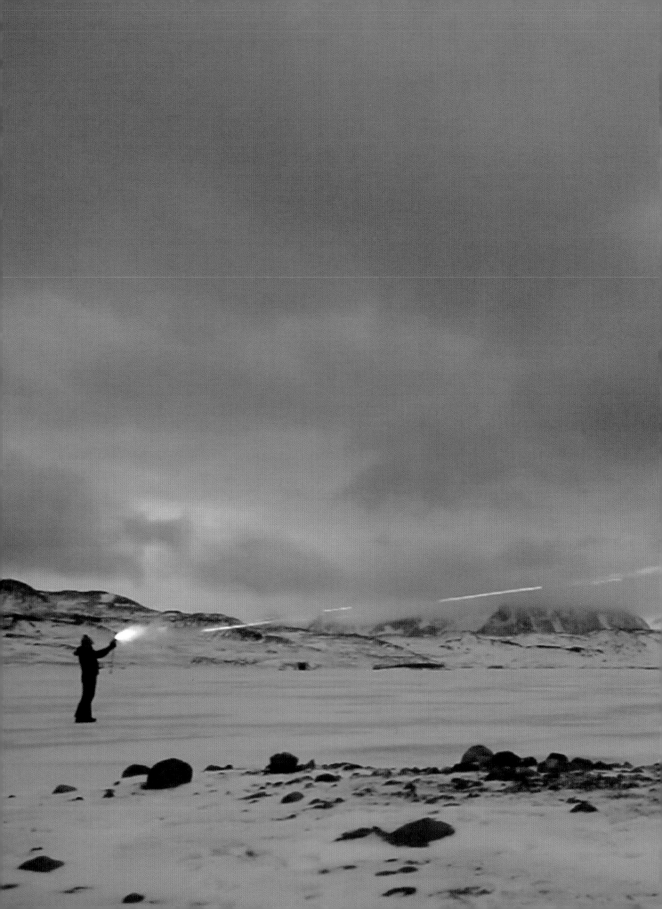

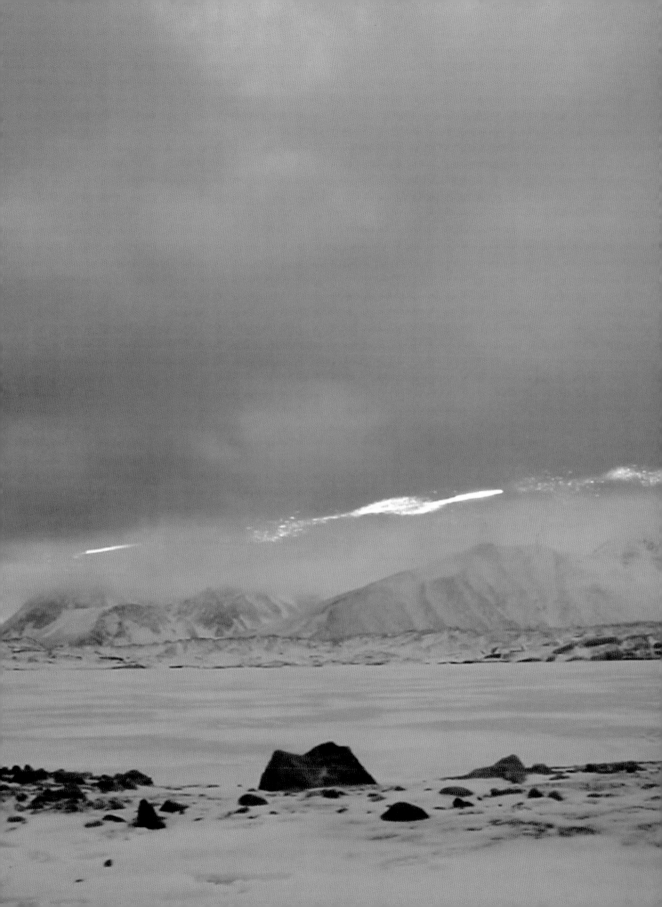

Brightness All Around, 2011

Single-channel, high definition
video with sound, 16:9 format.

Running time: 00:08:36.

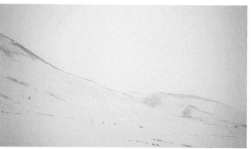
00:18

00:29

00:40

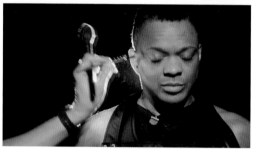
00:51

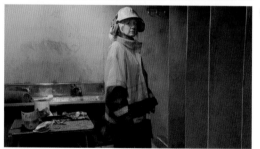
01:28

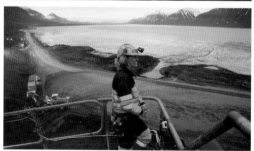

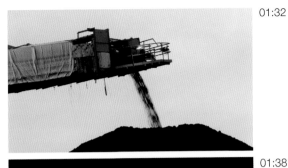
01:32

01:38

01:45

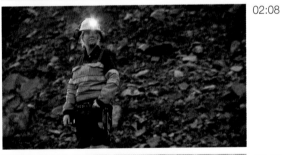
02:08

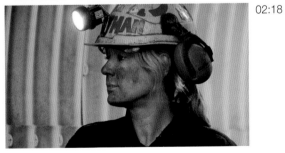
02:18

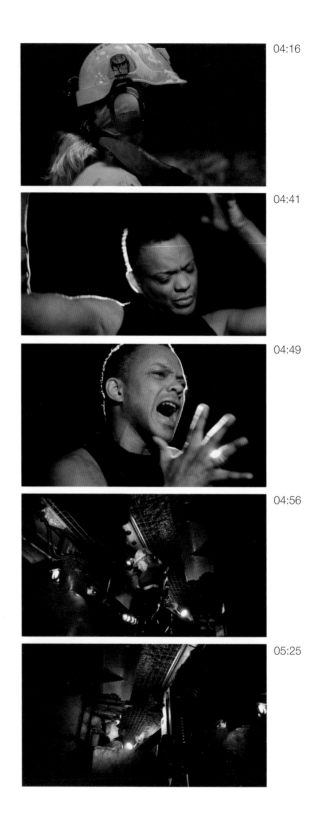

04:16

04:41

04:49

04:56

05:25

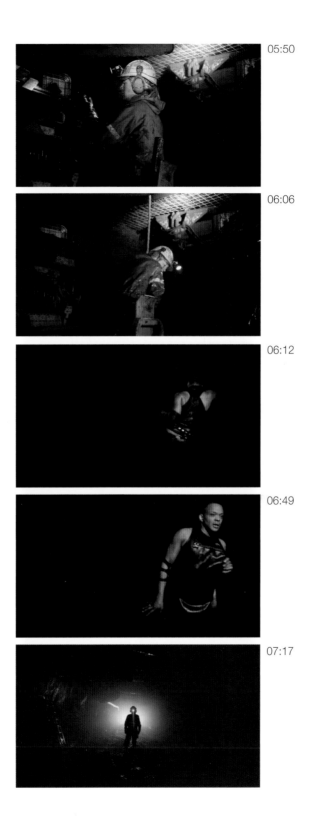

05:50

06:06

06:12

06:49

07:17

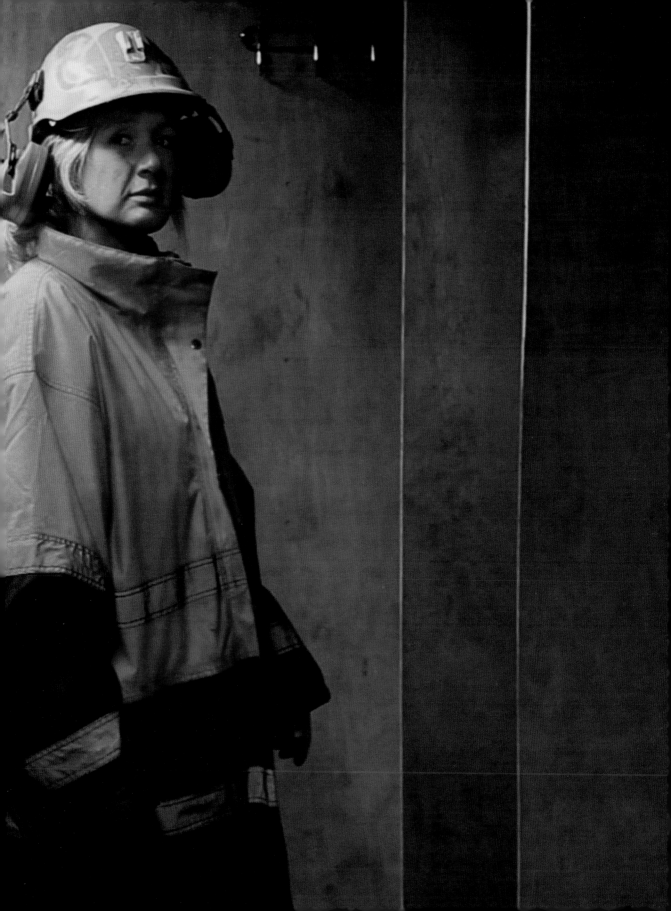

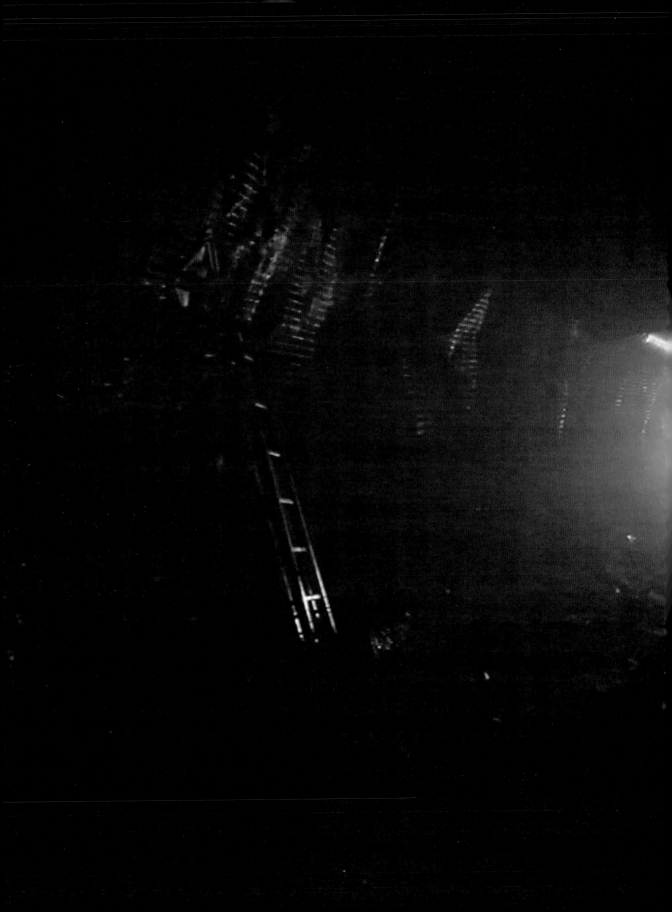

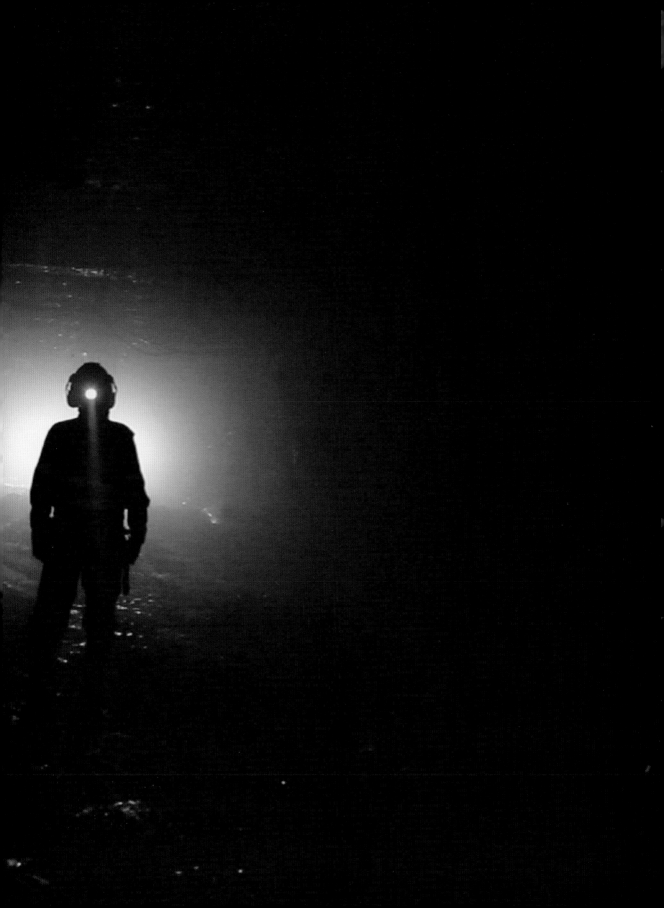

JANET BIGGS

Born 1959, Harrisburg, PA
Lives and works in New York, NY

SELECTED SOLO EXHIBITIONS/SCREENINGS

2012

Musée d'art contemporain de Montréal, Montréal, Canada

Randsucher, Glaskasten Marl Sculpture Museum,
Marl, Germany

Arctic Trilogy, Galerie Anita Beckers,
Frankfurt am Main, Germany

Airs Above the Ground, Artbox at the Stadtbibiliothek,
European Media Arts Festival, Osnabrueck, Germany

Kawah Ijen, Conner Contemporary Art, Washington, DC

Arctic Trilogy, presented as part of the Environmental Film
Festival at the Hirshhorn Museum, Washington, DC

2011

No Limits: Janet Biggs (Survey exhibition), Tampa Museum
of Art, Tampa, FL

The Arctic Trilogy, Winkleman Gallery, New York, NY

Wet Exit (performance), presented by Smack Melon, part of
the Dumbo Arts Festival, Brooklyn, NY

2010

Vantage Point IX: Janet Biggs: Going to Extremes,
Mint Museum of Art, Charlotte, NC

Conner Contemporary Art, Washington DC

Vanishing Point, McNay Art Museum, San Antonio, TX

2009

Vanishing Point, Claire Oliver Gallery, New York, NY

Janet Biggs and Anthony Gonzales (M83). Part of the River
to River Festival, World Financial Center, New York, NY

Perth Institute of Contemporary Arts Screen Space,
Perth, Australia

2008

Tracking Up, Solomon Projects, Atlanta, GA

2007

Enemy of the Good, multi-media performance,
Miami, FL

Gibbes Museum of Art, Charleston, SC

2006

Hit Me With Your Rhythm Stick, multi-media performance,
Miami, FL

Like Tears in Rain, Claire Oliver Gallery, New York, NY

Behind the Vertical, Hermés New York Flagship Store,
New York, NY

Dance Theatre Workshop, New York, NY

2005

Rules of Engagement, multi-media performance, New York, NY
(In collaboration with choreographer JoAnna Mendl Shaw)

2004

The Galleries at Moore, Moore College of Art and Design,
Philadelphia, PA

University of Connecticut Contemporary Art Galleries,
Storrs, CT

Rhode Island School of Design Museum,
Providence, RI

Solomon Projects, Atlanta, GA

2002

Herbert F. Johnson Museum of Art, Cornell University,
Ithaca, NY

2001

Team Gallery, New York, NY

Plains Art Museum, Fargo, ND

Western Gallery, Western Washington University,
Bellingham, WA

2000

Cincinnati Contemporary Art Center, Cincinnati, OH

Solomon Projects, Atlanta, GA

1999

Zilkha Gallery, Wesleyan University, Middletown, CT

John Michael Kohler Arts Center, Sheboygan, WI

1998

Everson Museum of Art, Syracuse, NY

1997

Anna Kustera Gallery, New York, NY

Solomon Projects, Atlanta, GA

1996

Chassie Post Gallery, New York, NY

SELECTED GROUP EXHIBITIONS

2012

True North, Anchorage Museum, Anchorage, AK

Speed: The Art of the Performance Automobile, Utah Museum Of Art, Salt Lake City, UT

Video 2012, Momenta Gallery, Brooklyn, NY

2011

Videonale: Dialog in Contemporary Video Art, National Taiwan Museum of Fine Arts (NTMoFA), Taichung, Taiwan

Videonale 13, Kunstmuseum Bonn, Germany Travelling exhibition: GOMA, Glasgow Gallery of Contemporary Art, UK; Ars Cameralis, Katowice, Poland)

She Devil, Museo D'Arte Contemporanea Roma, Italy

2010

Sidewalk Moving Picture Festival, Birmingham, AL

2009

Miami International Film Festival, "Cutting the Edge," Miami, FL

Vanishing Point included in *Chimera*, Envoy Enterprises in New York, NY, and Arcade Experimental Art Projects / Stoa Aeschylou in Nicosia, Cyprus

2008

Young Identities (part of European Media Art Festival), Kunsthalle Dominikanerkirche, Osnabrück, Germany

Oslo Screen Festival, Oslo, Norway

Hollywould... , Freewaves 11th International Festival of New Media Arts, Los Angeles, CA

Water, Carroll Square Gallery, Washington, DC

Video Screenings, Sara Meltzer Gallery, New York, NY

2007

Keeping Up With the Jones, Schroeder Romero Gallery, New York, NY

Infinitu et Contini: Repeated Histories, Reinvented Resistances, Smack Mellon, Brooklyn, NY

Lumen Eclipse, outdoor video installation, Cambridge Square, Boston, MA

stop. look. listen: An Exhibition of Video Works, Herbert F. Johnson Museum of Art, Cornell University, Ithaca, NY. Travelling exhibition: Haggerty Museum of Art, Marquette University, Milwaukee, WI

North Sea Film Festival for Underwater Movies, the Hague, Netherlands

Contemporary, Cool and Collected, Mint Museum of Art, Charlotte, NC

Antennae, Houston Center For Photography, Houston, TX

2006

METU Video Festival, Middle Eastern Technical University, Ankara, Turkey

Claire Oliver Gallery, New York, NY

2005

Artists Pick, Larissa Goldston Gallery, New York, NY

FATHOM, Hatton Gallery, University of Newcastle, Newcastle, U.K.

2004

PG-13 (Two-person exhibition with Barbara Pollack), Georgia State University Gallery, Atlanta, GA. Travelling exhibition: DiverseWorks, Houston, TX

Dwellan – Lingering Images, Charlottenborg Exhibition Hall, Copenhagen, Denmark

Video X: Ten Years of Video with Momenta Art, Momenta Art, Brooklyn, NY

2003

Home Grown, Linköpings Konsthall Passagen, Linköpings, Sweden

Venden Varassa (Dominated by Water), Vantaa Art Museum, Finland

H_2O, Santa Fe Art Institute, Santa Fe, NM. Travelling exhibition: Danese Gallery, New York, NY; Houghton House Gallery, Hobart and William Smith Colleges, Geneva, NY; Elaine L. Jacob Gallery, Wayne State University, Detroit, MI; Western Gallery, Western Washington University, Bellingham, WA

2002

New York, New Work, Now!, Currier Gallery of Art, Manchester, NH

Aquaria: On the Interaction of Water and Human Being. Travelling exhibition: Oberösterreichisches Landesmuseum, Linz, Austria; Kunstsammlungen Chemnitz, Germany

Residuum, Cheryl Pelavin Fine Art, New York, NY

Arrested Development: Contemporary Contemplations on Youth Culture, Castle Gallery, College of New Rochelle, New Rochelle, NY

2001

Objects in Mirror Are Closer Than They Appear, Team Gallery, New York, NY

Horse Tales: Two Centuries of American Cultural Icons, Katonah Museum, Katonah, NY

2000

Objects That Flicker, Solomon Projects, Atlanta, GA

human/nature, Caren Golden Fine Art, New York, NY

Horse Show, Site Gallery, Sheffield, U.K.

6 Signals: Video Art by Contemporary Artists, Cheekwood Art Museum, Nashville, TN

Object Lessons: Selections from the Robert J. Shiffler Foundation, Columbus Museum of Art, Columbus, OH

Here Kitty Kitty, Nexus, Atlanta, GA

1999

The Comforts of Home, Hand Workshop Art Center, Richmond, VA

Horse Play (*BuSpar*, project room installation), Real Art Ways, Hartford, CT

1998

Flip Side Gallery, Brooklyn, NY

Installation 7: Conceptual Art, 1989-1995. Cheekwood Museum of Art, Nashville, TN

1997

Presumed Innocence, Anderson Gallery, Virginia Commonwealth University, Richmond, VA Travelling exhibition: Cincinnati Contemporary Art Center, Cincinnati, OH

Girls and Horses (project room installation, part of *Family/PostFamily, m.a.p.:media art project 1997*), Vantaa Art Museum, Finland

The Gaze, Momenta Gallery, Brooklyn, NY

1996

Romper Room, Thread Waxing Space, New York, NY

B.A.B.Y., Virginia Beach Center for the Arts, Virginia Beach, VA

Kickstart, Anna Kustera Gallery, New York, NY

Embedded Metaphor, Independent Curators Incorporated, New York, NY. Travelling exhibition: Dalhousie Art Gallery. Dalhousie University, Halifax, Nova Scotia; Pittsburgh Center for the Arts, Pittsburgh, PA; Ezra and Cecile Zilka Gallery, Wesleyan University, Middletown, CT; Virginia Beach Center for the Arts, Virginia Beach, VA; Bowdoin College Museum of Art, Brunswick, MA; Western Gallery, Western Washington University, Bellingham, WA; John and Mable Ringling Museum of Art, Sarasota, FL

Separating Self: Art About Identity from the Robert J. Shiffler Collection, New Harmony Gallery of Contemporary Art, New Harmony, IN

Incestuous, Thread Waxing Space, New York, NY

Subversive Domesticity, Edward A. Ulrich Museum of Art, Wichita State University, Wichita, KS

This End Up: Selections from the Collection of Robert J. Shiffler, University of Wyoming, Laramie, WY. Travelling exhibition: South Dakota Art Museum, Brookings, SD; Cleveland Center for Contemporary Art, Cleveland, OH

1995

Chassie Post Gallery, New York, NY (Two-person show)

Galleria Civica di Padova, Padua, Italy

Wary Still, Highways Exhibition Space, Santa Monica, CA

1994

Night Light Room (Project room installation, part of Family Ties show), P.P.O.W. Gallery, New York, NY

Forms of Address, San Francisco Art Institute, San Francisco, CA

Regional Identity and Cartography Representation, Pigorini Museum, Rome, Italy

1993

Josh Baer Gallery, New York, NY (Two person show).

Beau Dommage, Jack Shainman Gallery, New York, NY

Fall From Fashion, Aldrich Museum of Contemporary Art, Ridgefield, CT

From the Collection of Robert J. Shiffler, Cincinnati Contemporary Art Center, Cincinnati, OH

I Am the Enunciator, Thread Waxing Space, New York, NY

1992

Josh Baer Gallery, New York, NY

Kunsthall, New York, NY

White Columns Gallery, New York, NY

1991

Shared Skin: Sub-Social Identifiers, Dooley Le Cappellaine Gallery, New York, NY

Four Walls, Brooklyn, NY

SELECTED EXHIBITION CATALOGUES/BROCHURES

Videonale, Dialogue in Contemporary Video Art.
National Taiwan Museum of Fine Arts, Taichung,
Taiwan, December 2011

Videonale.13 Festival for Contemporary Video Art.
Exhibition catalogue. Editor: Georg Elben.
Essay: Dirk Rustemeyer. Bonn, Germany. 2011

Janet Biggs: Going to Extremes. Vantage Point IX
Exhibition catalogue. Curator: Carla M. Hanzel. Essay:
Nancy Princenthal. Mint Museum of Art, Charlotte, NC.
November 2010

Inselmann, Andrea. *stop.look.listen an exhibition of video
works.* Herbert F. Johnson Museum of Art, Cornell, NY. 2008

European Media Arts Festival, Osnabrueck, Germany. 2008

Contemporary Cool and Collected. Curator: Carla M. Hanzel.
Essay: Robert Hobbs. Mint Museums, Charlotte, NC.
September 2007

Dwellan. Exhibition Catalogue. Editor: Marit Ramsing.
Essay: Kristine Kern. Charlottenborg Exhibition Hall,
Copenhagen, Denmark. 2004

Norms and Forms. Exhibition Catalogue. Essay: Brian
Wallace. The Galleries at Moore. Moore College of Art and
Design, Philadelphia, PA. 2004

Morales, René: *Videos in Progress: Janet Biggs.*
Exhibition essay. Rhode Island School of Design Museum,
Providence, RI. May 2004

*PG-13—Male Adolescent Identity in a Video Culture:
Video Work by Janet Biggs and Barbara Pollack.* Exhibition
Catalogue. Essay by Linda Yablonsky. Georgia State
University Ernest G. Welch School of Art & Design Gallery,
Atlanta, GA and DiverseWorks, Houston, TX

Isaak, Jo Anna: *H$_2$O.* Exhibition catalogue. Hobart and
William Smith Colleges Press, Geneva, NY. 2002

Inselmann, Andrea: *Janet Biggs.* Exhibition catalogue.
Herbert F. Johnson Museum of Art, Cornell University,
Ithaca, NY. August 2002

Wally, Barbara: *Aquaria: The Fascinating World of Man
and Water.* Exhibition catalogue. Stadtwerke Chemnitz AG,
Chemnitz, Germany. February 2002

Smith, Todd: *Verge: Janet Biggs.* Exhibition catalogue.
Plains Art Museum, Fargo, ND. July 2001

Harris, Jane: *Flight: Janet Biggs.* Exhibition brochure.
Wesleyan University, Middletown, CT. February 2000

Horse Tales: American Images and Icons. Exhibition
catalogue. Katonah Museum of Art, Katonah, NY. Preface
by Verlyn Klinkenborg. Essays by Ezra Shales, Susan H.
Edwards, and Deborah Bright. 2000

Inselmann, Andrea: *Up Downs.* Exhibition brochure. John
Michael Kohler Arts Center, Sheboygan, WI. 1999

*Mettlesome & Meddlesome: Selections From the Collection
of Robert J. Schiffler.* Exhibition catalogue. Cincinnati
Contemporary Arts Center, Cincinnati, OH. Foreword by
Center Director Elaine King, introduction by former Center
Curator Jan Riley, essay by New Museum Director Marcia
Tucker, statement by Robert Shiffler. 1998

Presumed Innocence. Exhibition catalogue. Forward by Jean
Crutchfield, Essays by Robert Hobbs and Kathryn Hixson.
Published jointly by the Anderson Gallery and the University
of Washington Press, 1997

The Gaze. Exhibition catalogue. Momenta Art, Brooklyn, NY.
Essay by Jan Avgikos, preface by Laura Parnes. 1997

Felshin, Nina: *Embedded Metaphor.* Exhibition catalogue.
Independent Curators; ISBN: 0916365484, January, 1997

B.A.B.Y. Exhibition catalogue. Hand Workshop Art Center
and the Virginia Beach Center for the Arts, Virginia Beach, VA.
Essay by Jan Riley. 1996

Porges, Maria: *Forms of address: the 113th Annual
Exhibition.* Exhibition catalogue. Walter/McBean Gallery,
San Francisco Art Institute, San Francisco, CA: Lynn Aldrich,
Janet Biggs, Jean LaMarr, Julian Lang, Canan Tolon.
6 October - 13 November 1994

Lichtenstein, Therese: "Multicultural Excavations."
Catalogue Essay in *Shared Skin: Sub-Social Identifiers.*
Dooley Le Cappellaine Gallery, New York, NY, 1991

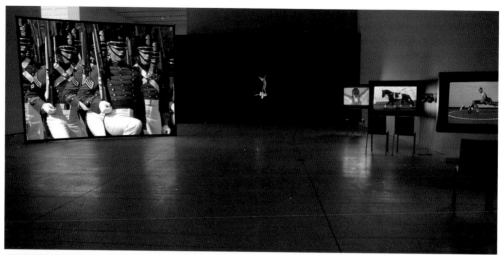

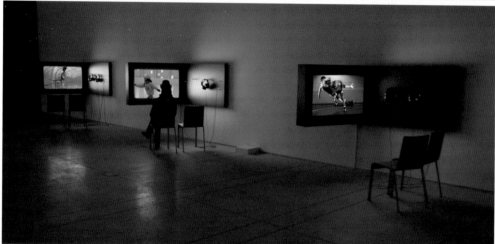

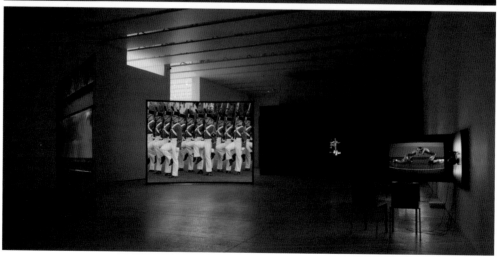

SELECTED REVIEWS/ARTICLES

Jenkins, Mark: "Janet Biggs Creates an Active Art Experience With 'Kawah Ijen'", *Washington Post*, 26 April 2012

Byrd, Cathy: Review of *No Limits: Janet Biggs* at the Tampa Museum of Art, *Art Papers*, January 2012

Voeller, Megan: "Excellent Adventurers." *Creative Loafing*, Atlanta, GA. 1 December 2011

Bennett, Lennie: "Conjecture key to comparison of Janet Biggs' video works at Tampa Museum of Art." *St. Petersburg Times,* 23 October 2011

Finch, Charlie: "Wetness Visible." *Artnet.com*, 1 November 2011

Pollack, Barbara: "Janet Biggs." *Art in America*, May 2011

Cotter, Holland: Review of show at Winkleman Gallery. *The New York Times*, 17 February 2011

Rifkin, Mark: "TWI-NY Talk: Janet Biggs." *This Week in New York*, 9 March 2011

Jeppessen, Travis: Review of show at Mint Museum. *ArtForum*, 26 January 2011

Finch, Charlie: "Coal Miner's Daughter." *Artnet.com*, 25 February 2011

Sutton, Benjamin, "Exploration Art: Janet Biggs and Duke Riley Scout Forgotten Islands and Dark Tunnels." *L Magazine*, 28 February 2011

Pollack, Barbara: Review of show at Conner Contemporary Art. *ARTnews*, November 2010

Wennerstrom, Nord: Review of show at Conner Contemporary Art. *ArtForum*, October 2010

Finch, Charlie: "White on White." *Artnet*, 21 June 2010

Conley, John David: "Janet Biggs on NASCAR, kayaks, and competition." Fauxrator.com, 15 June, 2010

McClemont, Doug: Best Ten Shows of 2009. Saatchi and Saatchi online magazine. January 2010

Finch, Charlie: "The Harvest of Art." *Artnet*, 17 July 2009

Finch, Charlie: "Groundhog's Diary." *Artnet*, 13 February 2009

Conner, Jill: Janet Biggs at Claire Oliver Fine Art (Review of *Vanishing Point*). Art Quips, 9 January 2009

"Janet Biggs." Review of *Vanishing Point*. *New Yorker*, 22 February 2009

Fester, Felicia: Review of *Tracking Up* at Nancy Solomon Gallery. ArtPapers, July/August 2008

Kurzner, Lisa: "Videos explore adolescents' accomplishments." *Atlanta Journal-Constitution*, 6 June 2008

Kasper, Chris: "Infinitu et Contini: Repeated Histories, Reinvented Resistances." *Art Papers*, March/April 2008

Diack, Heather: "Sign Language as Politics." *Afterimage*, Vol. 35, No. 5., March/April 2008

"Medienkunstfestivalim Zeichen der Jugend." *Mindener Tageblatt,* 28 April 2008

Jenks, Debra: "Pulp Friction - Artists explore the underside of American culture." *Chelsea Now*, 14 December 2007

"Keeping up with the Jones." Review of show at Schroeder Romero gallery, *The New Yorker*, 24 December 2007

Maschal, Richard: "Newly Minted: Private collectors lend their modern treasures as Mint museum starts a quest for living artists." *Charlotte Observer,* 19 October 2007

"Sport and Spectacle," *Artkrush* online magazine. 8 August 2007

Smith, Nick: "Future Noir: Janet Biggs mixed documentary shots for art's sake at the Gibbes." *Charleston City Paper*, 2 May 2007

Yale, Madeline: "Antennae" (review of group show at Houston Center for Photography). *Spot* Magazine, Summer 2007

Byrd, Cathy: "Janet Biggs." *Contemporary*, March, 2007

Perez, Magdalen: Review of show at Claire Oliver Gallery. *ARTNews*, February 2007

Li, Zhen: "Equestrians in Show Windows." *Vision Magazine*, Beijing, China. October 2006

Matsumae, Ayano: "Janet Biggs" (review of *Like Tears in Rain*, Claire Oliver Gallery, New York). *Nile Magazine* (Japan). December 2006

"Janet Biggs." Review of show at Claire Oliver Gallery. *The New Yorker*, 4 December 2006

Matsumae, Ayano: "Janet Biggs" (review of *Behind the Vertical* at Hermés, New York). *Nile Magazine* (Japan). November 2006

Perez, Magdalene: "Nearby Explosion Adds Extra Drama to Video Installation at Hermes." *ArtInfo*, 11 August 2006

Pollack, Barbara. "Horseplay." *ArtNews*, Summer 2006

Dunning, Jennifer: "A Horse and Dancers in an Ode to Interspecies Ties." *New York Times*, 10 October 2005

Lille, Dawn: "Rules of Engagement: Dancers and a Horse." *Art Times*, December 2005

Marshall, Lea: "Rules of Engagement" review. *Dance Magazine*, November 2005

Tobias, Tobi: "Rules of Engagement." *New York Village Voice*, 1 November 2005

Anderson, Jack: "Rules of Engagement" review. *New York Times,* 14 October 2005

Pollock, Barbara: "Moonlight Sonata." *ARTNews*, September 2005

Gavin, Francesca: "Drowning in Newcastle." *BBC online*, 21 July 2005

Jones, Sarah: Review of *Fathom*. *Metro* (Newcastle, UK). 8 July 2005

Whetstone, David: "Sound Creation for World of the Deep." *The Journal* (Newcastle, UK), 2 July 2005

Duff, Helen: "Fathom." review. *Metro* (Newcastle, UK). 30 June 2005

Pohl, Eva: Videopoesi på højt niveau." *Berlingske* (Copenhagen), 11 November 2004

Hornung, Peter Michael: "Når billedet dvæler." *Politiken* (Copenhagen), 9 November 2004

Tommelleo, Donna: "Former UConn Players' Drills Become a Work of Art"
New York Newsday, 27 November 2004
Boston Globe, 27 November 2004
San Francisco Chronicle, 27 November 2004
Sports Illustrated, 27 November 2004
Stanford Advocate, 27 November 2004
Ms. Magazine Online, 27 November 2004

Pollack, Barbara: "H$_2$O." *Time Out New York*, 7-14 August 2003

Faingold, Scott: "Teenage Wasteland - Two artists ask how boys become men in a videocracy." *Houston Press*, 11 March 2004

Hirsch, Faye: "Janet Biggs at the Herbert F. Johnson Museum of Art." *Art in America*, July 2003

Sohl, Lena: "USA underytan" (USA Under the Surface). *Stockholm Aftonbladet,* 9 May 2003

Ulmonen, Anu: "Syväsukellus mieleen ja ruumiiseen" (Deep Dive Into Mind and Body). *Helsinki Sanomat*, 18 January 2003

Sozanski, Edward J.: "Bodies in Motion." *Philadelphia Inquirer*, 4 December 2004

Ripatti-Torniainen, Leena: "Janet Biggsin uimari liikkuu kuin unessa" (Janet Biggs' swimmer moves as if in a dream). *Vantaan Sanomat* (Vantaa, Finland), 19 January 2003

Höll, Von Andreas: ''Aquaria - Über die außergewöhnliche Beziehung von Wasser und Mensch.'' DeutschlandRadio Berlin, 5 May 2002

Miller, Barbara: Review of *Flight* and *BuSpar* at Western Washington University. *Art Papers Magazine,* September/October 2001

Relyea, Kie: "Video artist circles back to WWU." *The Bellingham Herald,* 5 April 2001

Byrd, Cathy: Review of *BuSpar* at Solomon Projects. *Sculpture Magazine*, June 2000

Cullum, Jerry: "Emotional Equestrianism." *Atlanta Journal-Constitution,* Atlanta, GA. 21 January 2000

Feaster, Felicia: "Whipped." *Creative Loafing*, Atlanta, GA. 26 January 2000

Pollack, Barbara: "The Mane Event." *ARTnews,* November 1999

Rush, Michael: "Fire and Water, Three Media Installations." *Performance Arts Journal No. 58*, The Johns Hopkins University Press, September 1998 (Cover)

Williams, Gregory: Review of *Water Training* at Anna Kustera Gallery. *Zing Magazine*, Fall 1998

Zimmer, William: "Inviting or Not, What Do Beds Mean?" *New York Times*, 4 October 1998

Bergman, Aeron: Review of *Water Training* at Anna Kustera Gallery. *Cakewalk*, Spring/Summer 1998

Auslander, Philip: Review of *Water Training* at Nancy Solomon Gallery. *Art Papers,* March-April 1998

Yablonsky, Linda: Review of *Water Training* at Anna Kustera Gallery. *Time Out New York*, 11 December 1997

Forrest, Jason A.: "Janet Biggs: Water Training—Learning to Ask Questions." *The Journal-Constitution* (Atlanta), 24 October 1997

Byrd, Cathy: Review of *Water Training* at Solomon Projects. *Creative Loafing*, Atlanta, GA. 11 October 1997

Lipsasen, Ulla: "Perhe Murroksessa." *Artmagazine* (Helsinki, Finland), November 1997

Marta-Terttu Kivirinta: "Kenellä on oikeus perhe-elämään?" *Helsinki Sanomat* (Helsinki, Finland), 18 September 1997

Marja-Liisa Lappalainen: "Onnea Ja Helvettiä." *Ilta-Sanomat* (Helsinki, Finland), 18 September 1997

Qualls, Larry: "Five Video Artists." *Performance Arts Journal No. 54*, The Johns Hopkins University Press, September 1996

Schwendener, Martha: Review of *Girls and Horses* at Chassie Post Gallery. *Art Papers,* May/June 1996

Hess, Elizabeth: "It Takes a Village." *Village Voice,* 26 March 1996

Halle, Howard: Review of *Girls and Horses* at Chassie Post Gallery. *Time Out New York,* 20 March 1996

Tanner, Marsha: Review of show at San Francisco Art Institute. *Art Issues,* November 1994

DiGenova, Arianna: "Figure Erranti Oltre la Mappa del Identita Correnti." *Il Manifesto* (Rome, Italy). 15 June 1994

Rossi, Leena-Maija: "Lapsuuden loppu." *Helsingin Sanomat.* Lauantaina 29, Tammikuuta, 1994

Heartney, Eleanor: "Elizabeth Berdann and Janet Biggs at Josh Baer." *Art in America,* May 1994

Levin, Kim: "Voice Choices." Review of show at Josh Baer Gallery. *Village Voice,* 28 December 1993

DiGenova, Arianna: Review of *Giochi Nell'Acqua. Titolo* (Perugia, Italy), August 1993

Liebenson, Bess: "What Do Clothes Mean, Anyway?" The *New York Times*, 8 August 1993

Raynor, Vivien: "What Do Clothes Mean to an Artist Anyway?" *New York Times*, 13 June 1993

Bonami, Francesco: "Panorama NYC." *Flash Art*, October 1992

Faust, Gretchen: "New York Reviews." Review of *Shared Skin: Sub-Social Identifiers. Arts Magazine,* January 1992

Smith, Roberta: "The Group Show as Crystal Ball." *New York Times*, 6 July 1990

COLLECTIONS

The Gibbes Museum of Art, Charleston, SC

Hadley Martin Fisher Collection, Miami, FL

The Herbert F. Johnson Museum of Art,
Cornell University, Ithaca, NY

The High Museum of Art, Atlanta, GA

The Mint Museum of Art, Charlotte, NC

The New Britain Museum of Art,
New Britain, CT

The Robert J. Shiffler Collection and Foundation,
Dayton, OH

The Tampa Museum of Art, Tampa, FL

1983-1984
Graduate Studies, Rhode Island School of Design,
Providence, RI

1979-1982
B.F.A., Moore College of Art, Philadelphia, PA

1977-1978
Experiment in International Living,
Basel, Switzerland

GRANTS & AWARDS

2011

WET EXIT Performance Sponsorship: The Walentas Family
and Two Trees Management, Brooklyn, NY. This project was
also partially funded by Smack Mellon, the New York City
Department of Cultural Affairs, the New York State Council
on the Arts, the Andy Warhol Foundation for the Visual Arts,
and The Concordia Foundation

Experimental TV Center Finishing Funds award,
supported by the Electronic Media and Film Program
at the New York State Council on the Arts

2010

Art Matters: Artist's Project Grant

The Arctic Circle – High Arctic expedition residency:
The Arctic Circle administered by the Farm Foundation for
the Arts and Sciences

The Arts and Science Council of Charlotte –
Mecklenburg, Inc.: Exhibition Sponsorship,
Mint Museum of Art

Goodrich Foundation: Exhibition Sponsorship,
Mint Museum of Art, Charlotte, NC

2009

New York State Council on the Arts:
Film & Media / New Tech Production Grant through
the Experimental Television Center

Hermés of Paris: Production Funding

Bank of New York Mellon: Production Funding

The Arctic Circle – High Arctic expedition residency:
The Arctic Circle administered by the Farm
Foundation for the Arts and Sciences

2008

Experimental TV Center Finishing Funds award,
supported by the Electronic Media and Film Program
at the New York State Council on the Arts

2007-09

Hermés of Paris: Equipment Donation

2006

Hermés of Paris: Production Funding

2004

Anonymous Was a Woman Foundation Award

Wexner Center Media Arts Program,
The Ohio State University: film/video studio
program residency

2003

Panasonic (Finland): Equipment Donation

2001

Panasonic (USA): Equipment Donation

Wexner Center Media Arts Program, The Ohio State
University: film/video studio program residency

1997

Panasonic (Finland): Equipment Donation

1996

Sony Electronics Inc.: Equipment Donation

1990

Art Matters: Artist's Project Grant

1989

National Endowment for the Arts: Painting Fellowship

1988

The Leo Model Foundation: Project Grant

ESSAYS

Foreword
© Berta Sichel

The Verge, Janet Biggs
© Todd D. Smith, Plains Art Museum

Going Somewhere Fast:
Janet Biggs' *Vanishing Point*
© Andrea Inselmann

Janet Biggs: Mining the North
© Nancy Princenthal

PHOTO CREDITS

All photos courtesy of the artist,
CONNERSMITH., Washington,
DC, and Winkleman Gallery,
New York, NY.

Celeste in Her Bedroom (page 8):
Ellen Page Wilson.

Girls and Horses, installation view
at Chassie Post Gallery, New York,
New York (page 9): Erma Estwick.

BuSpar, installation view at Hatton
Gallery, University of Newcastle,
UK (page 10): Robert Cmar

John Glenn (page 12): Image
courtesy NASA.

Flight, installation view at
Vantaa Art Museum, Vantaa,
Finland (page14-15):
Robert Cmar.

BuSpar, installation view
at Tampa Museum of Art,
Tampa, Florida (page 18-19):
Robert Cmar.

Carpe Diem, installation view
at Tampa Museum of Art,
Tampa, Florida. (page 18-19):
Robert Cmar.

Like Tears in Rain, installation view
at Tampa Museum of Art,
Tampa, Florida (page 40-41);
Robert Cmar

Vanishing Point, installation view
at Tampa Museum of Art,
Tampa, Florida (page 56-57):
Robert Cmar.

Fade to White, installation view
at Tampa Museum of Art,
Tampa, Florida (page 72-73):
Robert Cmar.

Installation views at
Tampa Museum of Art,
Tampa, Florida (page 86):
Robert Cmar

COVER
Still from the video *Vanishing Point*,
2009. Single channel video with
sound. Courtesy of the artist,
CONNERSMITH., Washington,
DC, and Winkleman Gallery,
New York, NY.

DESIGN
Kabalab, NYC
www.kabalab.com

PRINTING
Mantec, Hong Kong

EDITOR
Page Leggett
Robert Cmar

Tampa Museum of Art
120 W. Gasparilla Plaza
Tampa, FL 33602
813/274-8130 phone
813/274-8732 fax
www.tampamuseum.org

Catalogue © 2012
Tampa Museum of Art

ISBN: 978-0-615-63518-7

Tampa Museum of Art